ENRICH
Your PAINTINGS *With*
TEXTURE

DAVID M. BAND

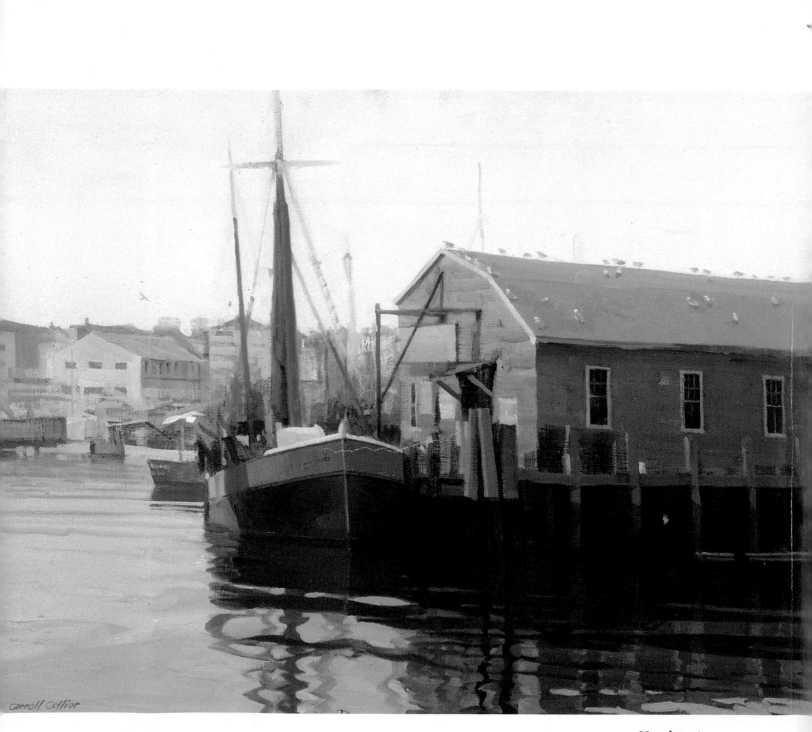

Morning at Gloucester
Carroll Collier
Oil on canvas
18″ × 24″

ELEMENTS OF PAINTING SERIES

ENRICH *Your* PAINTINGS *With* TEXTURE

DAVID M. BAND

NORTH LIGHT BOOKS

Cincinnati, Ohio

About the Author

David M. Band has devoted the majority of his life to art as a student, practicing artist, teacher and collector. He is primarily self-taught even though he received an art scholarship to the University of Maine.

With watercolor as his medium of choice, Band also works in oil and acrylics from large abstracts to miniatures of all subjects. Band has taught at the Wichita Falls Museum and Art Center, conducted workshops, private instruction and lectures on the collecting of fine art and methods of conservation.

His work can be found in private and corporate collections throughout the country including the United States Air Force Collection, Washington D.C.

Enrich Your Paintings With Texture. Copyright © 1994 by David M. Band. Printed and bound in China. All rights reserved. No part of this book may be reproduced in any form or by any electronic or mechanical means including information storage and retrieval systems without permission in writing from the publisher, except by a reviewer, who may quote brief passages in a review. Published by North Light Books, an imprint of F&W Publications, Inc., 1507 Dana Avenue, Cincinnati, Ohio 45207. 1-800-289-0963. First edition.

This hardcover edition of *Enrich Your Paintings With Texture* features a "self-jacket" that eliminates the need for a separate dust jacket. It provides sturdy protection for your book while it saves paper, trees and energy.

97 96 95 94 93 5 4 3 2 1

Library of Congress Cataloging in Publication Data

Band, David M.
 Enrich your paintings with texture / by David M. Band.
 p. cm. — (Elements of painting series)
 Includes index.
 ISBN 0-89134-515-9
 1. Painting—Technique. 2. Texture (Art) I. Title. II. Series: Elements of painting.
ND1500.B22 1994
751.4—dc20 93-48772
 CIP

Edited by Rachel Wolf and Kathy Kipp
Interior design by Paul Neff

Cover art by David M. Band was selected for the 169th annual exhibition of the National Academy of Design, New York, NY.

Thanks to each artist for their permission to reproduce artwork in this book.

Dedication

I wish to dedicate this book to the memory of my good friend, Letterio Calapai. Painter, printmaker, teacher and devoted husband to Jean.

Letterio Calapai
(1902-1993)

Acknowledgments

I wish to extend my sincerest appreciation to Rachel Wolf, my editor and friend, for her understanding, knowledge and guidance.

My heartfelt thanks to the artists for their time and generous contributions. And to Mary, Glenda, Bruce and Betty for their emotional support and technical assistance.

Contents

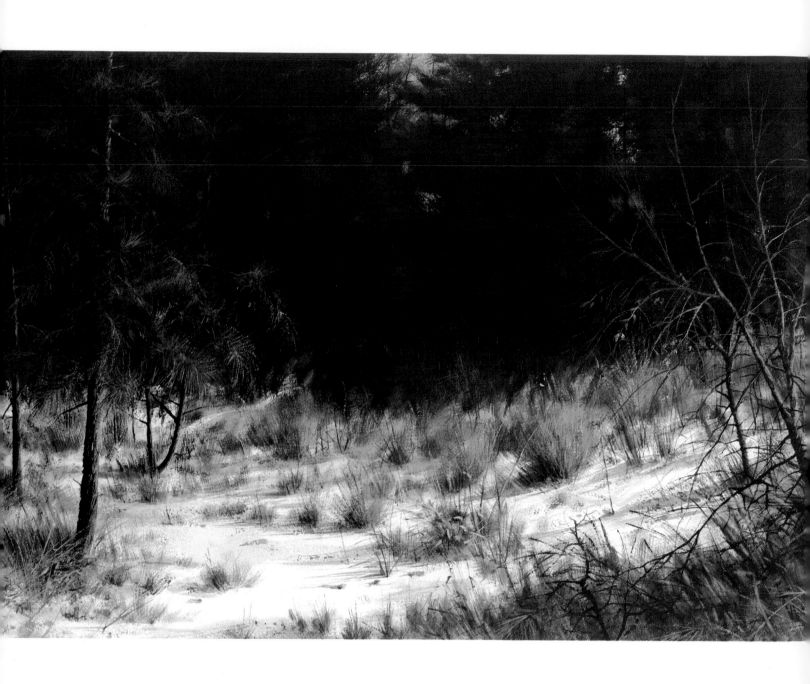

Introduction

Painting is one of the primary ele-
ments of the total art language, and
texture performs as the adjective
we use to illuminate the descrip-
tive aspects of our work.

The definition of texture is:
something composed of closely in-
terwoven elements, an essential
part or identifying quality. Simply
put, it means *characteristics*.

An example of this would be the
holes, cracks and decay found in
old weathered wood. These things
are the identifying qualities or
characteristics of the old wood and
are some of the more obvious
things that provide its texture.

Texture can also maintain a con-
sistency of color or enable color to
burst in a wide range of hues,
shades, tints and tones. Texture
can be developed on the painting
surface with various materials or
the surface itself can provide the
texture depending on its natural
character. How we see texture and
the methods we use to produce it
in our work is an individual process
that requires experimentation and
practice.

There are no rules or formulas,
only our imagination and whatever
it takes to make it work. Each me-
dium has its own unique qualities.
Sometimes combining a few medi-
ums like watercolor and pastel can
produce unusual and interesting ef-
fects, so experimentation is highly
recommended. It might provide
that something special you are
looking for.

Too often when we think of tex-
ture, it is something three dimen-
sional or having an exaggerated or
raised surface with patterns. What
about an object or a surface that
has to be touched to determine the
texture, like glass or cotton? Then
there is the emotional aspect of
texture, a feeling or something you
sense as a result of the texture of
atmosphere and space.

Atmosphere and space are cre-
ated in a painting by developing
texture in various ways. Heavy, de-
tailed texture shortens distance by
bringing the focus of a painting for-
ward, whereas softer less defined
texture enhances space by causing
the objects or forms to recede.
However it is used, texture is es-
sential for creating mood, and
mood is the emotional quality of at-
mosphere.

The generous contributions of
some very fine and dedicated art-
ists are presented in this book as a
comprehensive cross-section of
styles, mediums and subjects. All
have in common a deeply personal
view of the varieties and qualities
of texture, and all have successfully
used texture to enrich their paint-
ings.

Experiment with the techniques
shown in this book. Have fun and
add your own ideas. Whether you
are a beginning artist or an accom-
plished painter, gaining skill and
confidence in creating textures will
enrich and strengthen your own
paintings.

—David Band

Chapter One
Understanding Texture

Sand Road
Kent Day Coes
Watercolor
22″ × 30″

Sand Road is a powerful painting packed with mood and atmosphere. Coes's ability to suggest detail and disguise it with soft blended textures is seen in the lush, thick grass and heavy foliage of the distant trees being enveloped by the dense, peaceful fog.

Understanding texture is as easy as taking a close look at ourselves and our surroundings. Texture is a characteristic of all things natural and manmade.

But what exactly is texture? It is the *weave* in a fabric, it is the *roughness* of tree bark and the *smoothness* of glass. For the most part, texture has to do with the surface of things—but that isn't always the case. Grass can be *dry* or *moist* but it can also be *thick* or *sparse*. In the latter case texture is affected not only by surface characteristics but also by mass or volume.

We all use phrases like *soft* as velvet or *hard* as a rock. They produce mental images of objects based on texture. To understand these images one must have *touched* the objects at some time. If I said a *wrinkled* face or a *porous* rock, you would have to have seen them to make the connection and understand the texture. Putting it simply, *touching* and *seeing* are essential for understanding texture.

As artists, we have the freedom to create our own textures by the way we use our materials or by the style we choose. Design, patterns and strokes are effective ways of creating texture in realistic as well as abstract work.

Seeing and touching, along with experimentation and creativity, provide all of the essentials for understanding and using texture. No matter what the subject, texture is that special quality that gives body to color and character to form.

Texture and Strokes

Developing texture with strokes has been a favorite of many artists because it communicates energy and emotion. The stroke is used to create balance, rhythm and texture and can be an identifying characteristic of an artist's work, much like a fingerprint or signature. The most commonly used strokes are hard edged for strong contrasts and soft edged for producing gentle, blended and muted textures.

There is an overpowering sense of freedom in heavy, broad strokes loaded with paint and applied with energy, emotion and instinct. On the other hand there is security and comfort in the fine, controlled painterly strokes of carefully rendered subjects. Whatever approach is used, it still adds up to texture.

In the work of Ila McAfee, F. Luis Mora and George M. Bruestle, there is a fine blending of both hard- and soft-edged strokes that provides a pleasing textural balance throughout their work.

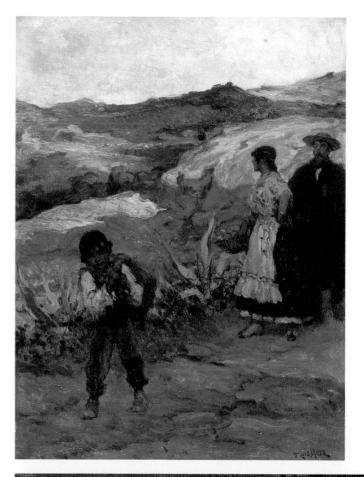

Figures in a Landscape
F. Luis Mora
Oil on canvas
16″ × 12″

In Mora's work several layers of thin gestural strokes pull the figures and landscape together with a gentle, rhythmic texture. The strokes seem to be working their way toward the figures and making them an integral part of the landscape. (Detail at right.)

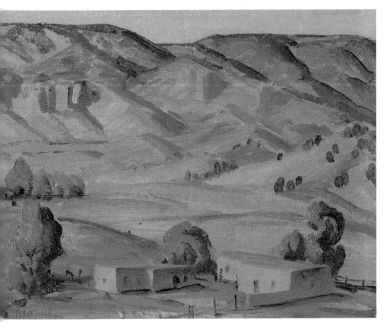

Chimayo Valley
Ila McAfee
Oil on board
8" × 10"

McAfee's simplistic, direct approach to texture is very effective in creating atmosphere and space by integrating both hard- and soft-edged strokes in a direct and expressive manner.

Detail

Notice how the flat angular strokes set the mood and the soft curving strokes offer balance.

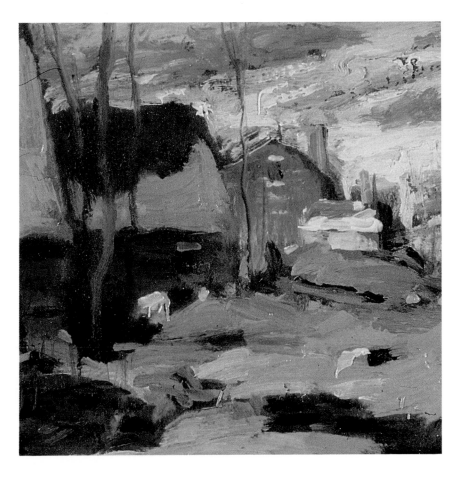

New England Winter (detail)
George M. Bruestle
Oil on panel
8" × 10"

Bruestle has conveyed mood in this painting with his bold, gestural strokes. Both soft and hard edges complement the subject and produce strong, energetic texture, without detracting from the subject and composition.

Abstract Textures

The word *abstract* is usually applied to just about anything that doesn't appear realistic or representational or that doesn't conform to our ideas of traditional art.

I like to think of abstraction as a playground of ideas. It offers endless possibilities for expression and experimentation with color, form and texture. Whenever I feel my representational work lacking or I become too wrapped up in exactness or detail, abstraction is a useful tool for loosening up and regaining my balance. Developing texture in abstraction is actually no different than in representational painting. The painting surface, paint, brushes and knives are the same, but color and form are less restricted. Here you can play with layering and building color and form and you'll find that abstraction is full of surprises.

I like to do abstract work on both canvas and paper. When I work on paper I prefer a heavy paper with a rough texture. I gesso both sides before using it. *Mixed Emotions* and *Adobe Wall, Twilight* are both acrylic on paper. *Mixed Emotions* is on white gesso and *Adobe Wall, Twilight* is on black gesso.

By using a series of washes first, then slowly building the surface with heavier application, I gradually developed the base textures. As the composition or strong points emerged from the washes, I used thicker paint to build and texture the final painting.

Mixed Emotions (left)
David Band
Acrylic on paper
25" × 18"
Collection of John and Karen Montgomery

In this painting I used acrylic like watercolor by applying several washes of yellow ochre and ivory black. Several layers of base textures were gradually built up by scumbling red, yellow ochre and black. In the final stage the purple, blue and white were mixed with gel medium to give the paint a creamy consistency and a slick, transparent texture.

Detail

In the close-up (right) you can see the layering, washes and individual textures. The background wash creates a sense of depth with a transparent field for the heavier strokes to float on.

Adobe Wall, Twilight
David Band
Acrylic on paper
22" × 30"
Collection of John and Karen Montgomery

For this painting I used black gesso to prepare the paper because of the depth and richness it gives to the paint. It has a way of making the colors appear to be floating or detached from the surface.

Each layer of paint was mixed with gel medium to give it a transparent quality so that each layer works with the previous one without covering the developing texture.

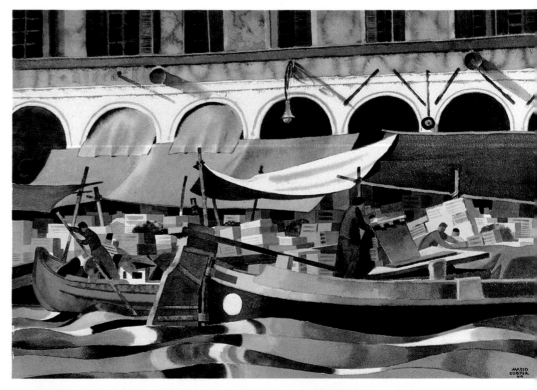

Texture by Design

Texture by design is a very sophisticated and time-consuming method requiring lots of planning, preliminary sketches, color studies and discipline, but the results can be truly stunning. With this method, not the painting surface but style and execution are the key elements. One method to create texture by design is to reduce the subject to its simplest shapes and then use those shapes as design elements. By relating the shapes in an interdependent manner, unique and expressive patterns emerge creating fascinating visual textures. Mario Cooper is a master of this technique. Cooper's painting *Venetian Market* shows the importance patterns and design can have in developing texture.

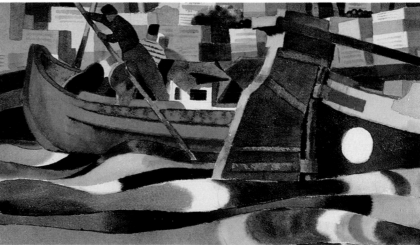

Venetian Market (top right)
Mario Cooper
Watercolor
22″ × 30″

In this painting the meticulously developed patterns and design create truly unusual and unique textures. A sense of motion is felt in the water with the flowing rhythmic texture in the ripples. Every segment of this painting offers different textures created with patterns and design.

Detail (center)

The design in the ripples and the patterns created by the reflections give the water a believable sense of motion.

Detail (right)

By careful color selection and well-thought-out contrasts the design elements work harmoniously for movement and depth.

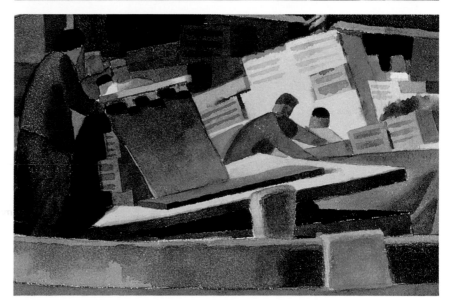

Texture and Surface

The energy and character of texture are profoundly affected by the painting surface. When selecting a surface, I find it useful to select one that will be compatible with the subject and my painting style.

In the art world there is a plentiful supply of materials with a wide variety of surfaces. For the experimenter who is looking for something unusual, there are many different and unique boards and materials to be found at lumberyards or home building centers. Modeling paste, gesso and creative brushwork are ideal for creating deep, richly textured surfaces. Adding sand or crushed stone to the paste can produce a "tooth" on the surface and is excellent for pastellists. This "tooth" has a way of holding the pigment, building texture and giving the colors a depth and richness that is more difficult to achieve with smooth surfaces.

No matter what medium you prefer, texture still requires creativity and a little help from tools such as erasers, razor blades, palette knives, fingernails, credit cards, keys, and just about anything you can find to produce the desired effect. John C. Pellew's watercolor *Milkweed* is an excellent example of using fingernails to create grass texture in a wet surface.

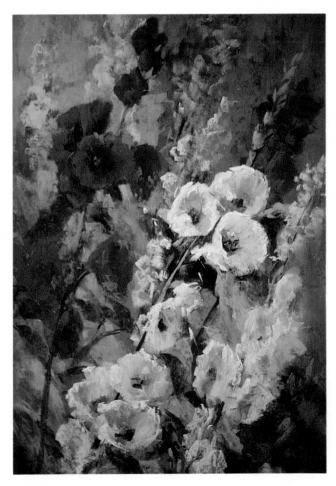

Hollyhocks II
Kaye Franklin
Pastel
20" × 14"

Franklin chose a fine-textured, German sanded paper for her surface. By using a controlled turpentine wash underpainting for the darks and midtones, she was able to create a base for developing the rich textures in the flowers and foliage.

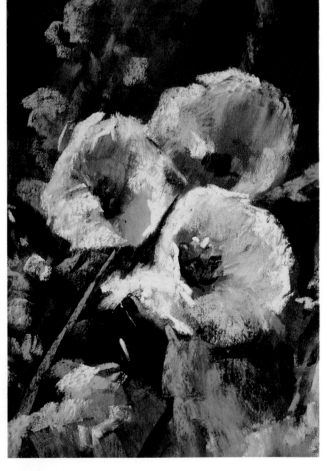

Detail

To achieve the velvety texture of the white hollyhocks, Franklin kept the tonal value high key. In the initial stages the soft floral textures were accomplished with minimal pressure by lightly dragging the pastel over the turpentine wash. This allowed selected areas of the underpainting to show through. The final highlights were added by using more pressure.

Milkweed
John C. Pellew
Watercolor
27" × 35"

Milkweed was painted on a hot-press surface using cadmium yellow light, cadmium orange, and burnt sienna in the grassy areas. While the paint was still wet, Pellew created the grass textures by lifting and scraping with his fingernails. The heel of a brush and the end of a brush handle will also work. Remember, the paint must be wet!

Textures, Light and Atmosphere

Lighting has a dramatic effect on texture and how we see it, both indoors and outdoors. Indoors, whether you are in a clean, polished environment like a museum or a dusty, dimly lit attic or cellar, light greatly affects the associated textures. Learn to observe and paint the light correctly and the rest of it will happen.

When considering textures associated with landscapes and cityscapes, we have to observe not only the surface of the subject, whether it is a building, tree, hills or a host of other things, but also the forces of nature such as rain, fog and snow. These elements along with light create atmosphere.

The textures created by a hazy or overcast day tend to be soft with less detail than you can see on a bright sunny day. Falling snow and fog have a blurring effect on surface texture, which accentuates mass rather than detail. Finding the balance between form and focus, taking into consideration the light, atmosphere and surface texture, is one of the challenges of landscape and cityscape painting.

We have only been able to touch upon a few areas here. Texture is truly in everything and everywhere. It has a unifying and bonding effect, punctuating and completing a painting.

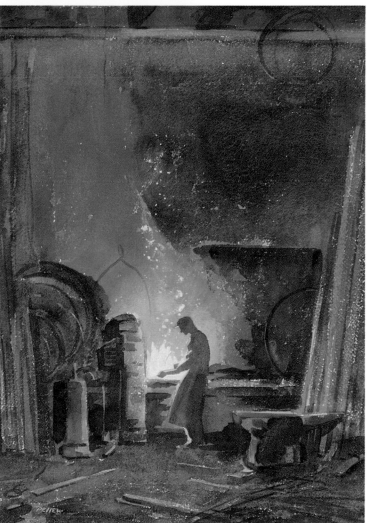

In this painting, Pellew used the light from the blacksmith's fire to capture the subtle textures of the shop's interior. The combination of rough paper with a dry-brush technique leaves broken and spotted textures of uneven flickering light.

Blacksmith
John C. Pellew
Watercolor
22½" × 16½"

Museum Morning #2
John C. Pellew
Watercolor
10″ × 14″

To effectively capture the smooth interior textures of a museum, with its polished reflective floors, Pellew used a hot-press watercolor board because of the smooth slick surface.

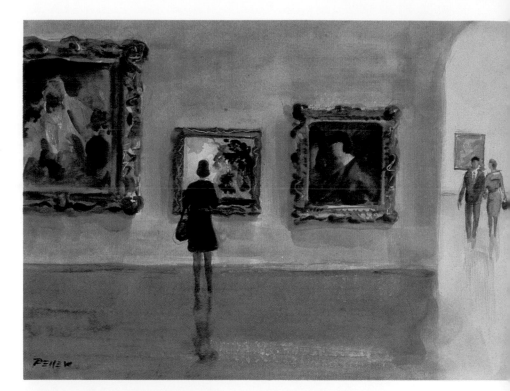

Iris Bud
David Band
Watercolor
3½″ × 5½″

This small painting is actually an exercise in texture. I was interested in how the background and plant would interact and how the light and texture would affect each other. The patterns of texture in the decaying plaster seem to be growing like the plant, creating an interaction among the texture, light and plant that gives movement to this still life.

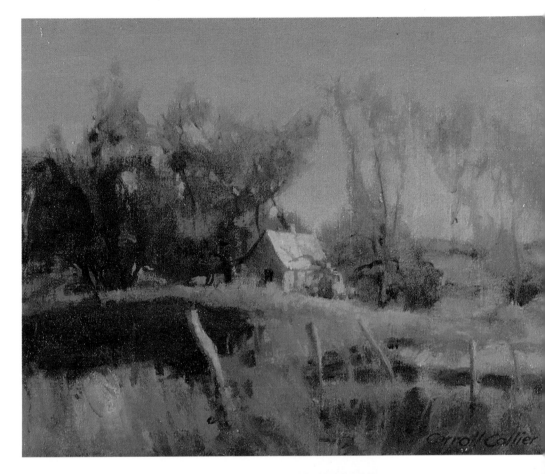

Country Place
Carroll Collier
Oil on canvas
9″ × 12″

Collier used his gentle fluid brushwork to convey a sense of peace and solitude. His softly blended textures suggest form in the distant tree line, depth in the grass, and contour in the land mass. Minimal detail and fading late afternoon light put the final touches on this painting.

Factory Workers
Henry M. Gasser
Oil
9″ × 12″

Gasser used a smooth board, building his texture with an abundance of bold gestural strokes and generous amounts of paint. Building texture with layering and strokes can create the illusion of detail.

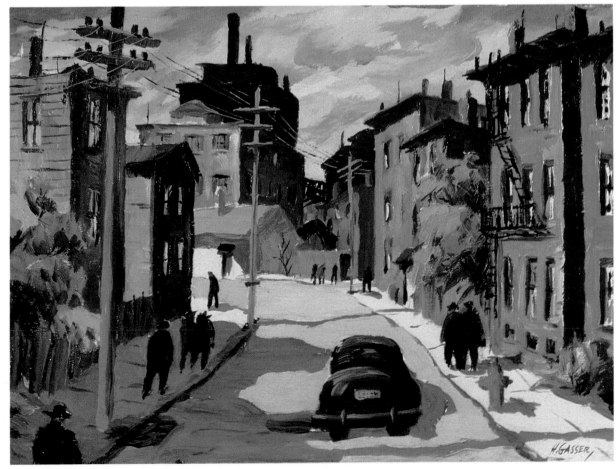

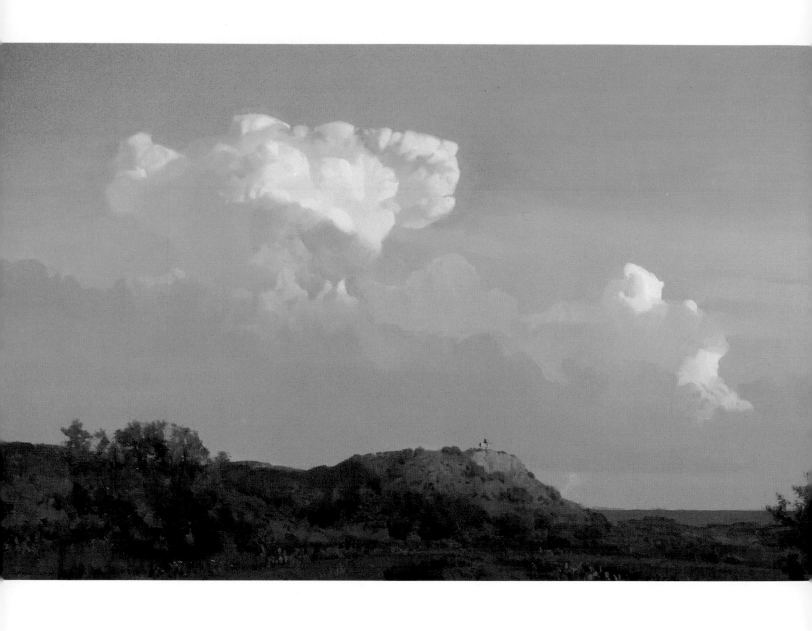

Chapter Two
Skies and Clouds

Thunderhead
Carroll Collier
Oil on canvas
30" × 46"
Photo courtesy Baker
Gallery, Lubbock, Texas

In my area of the country, I can see the horizon on all four sides. This cloud formation was from a photo I took from my side yard. Great skies! The landscape is typical of west Texas and New Mexico. It offers a pleasant contrast in color and texture, yet it echoes the grandeur of the sky with the hush of immensity. The late afternoon sun creates a melancholy mood—the end of a perfect day.

Skies play an important role in determining the mood of a painting. The mood is directly affected by the texture of the sky and the light it produces. Clear or flat skies provide an excellent background for foregrounds with fine detail or stark contrasts by reducing the confusion between sky and subject. In the same way, the impact of a dramatic sky can be intensified by a simple foreground, even one that is almost a silhouette. Finding the balance or harmony between sky and foreground textures is important.

Because skies are continually changing, they offer an endless supply of interesting lighting, patterns and textures. The unusual and dramatic sunsets of the Southwest, where I live, can change colors and patterns in a matter of minutes, so to ensure consistency in my paintings, I find it useful to take photographs and notes of skies for reference.

This approach is equally useful when trying to capture the rapidly changing light, textures and moods of angry, turbulent skies.

Sky Perspective

Although perspective is not something normally associated with skies, it is very important to understand how to use perspective when painting clouds. Without perspective, a cloud-filled sky will not have depth but will look flat and lifeless. By applying the same basic principles that are used for perspective in landscape, the problem is solved.

It's the same vanishing road, but instead of looking down, we look up. The largest clouds are overhead, then the clouds grow rapidly smaller toward the horizon. Cloud textures should be applied the heaviest in the foreground clouds and become less and less apparent toward the horizon.

There are three basic techniques you can use to achieve interesting skies in watercolor. On the following pages are demonstrations of these techniques.

Winter Trees
David Band
Watercolor
28" × 20"

With a highly detailed and contrasting foreground, a bright, flat sky works well to accentuate the shapes without drawing undue attention to itself.

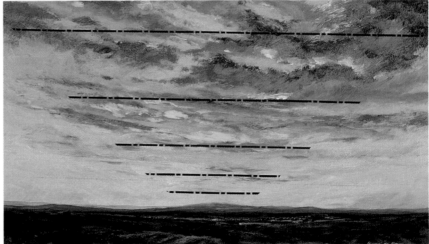

Perspective in sky painting is achieved by keeping the largest clouds overhead, with clouds becoming rapidly smaller as they move toward the horizon. Texture is handled in much the same way. It should be most pronounced in the clouds directly overhead and least visible in the clouds closest to the horizon.

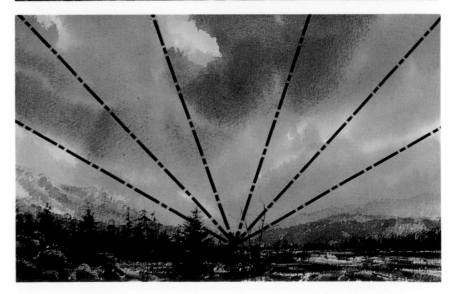

Here you can see how the "vanishing point" principle works in the sky. All lines advance toward a point on the horizon, as in landscapes.

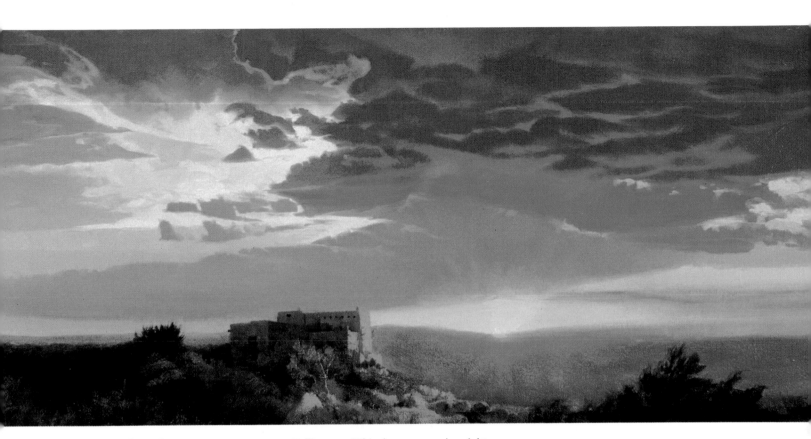

Symphony in Red
Carroll Collier
Oil on canvas
13" × 30"
Photo courtesy Baker Gallery,
Lubbock, Texas

Collier says, "This sky was a moving sight. It had great shape and color. The point of light, the sun, is a yellow tint. The radiating light moves away into orange and then red to cold red. The upper clouds are influenced by blue, giving a full spectrum of color but with red dominating. I photographed this sky and then made modifications in color and value from observation. At this time of day a sketch is not possible because every color and value is in constant change. The adobe placed just so in relation to the clouds was not a part of the photo, but placed in the picture to counterbalance the clouds and to stop the action of the cloud sweep to the left. The sky texture is smooth, as are the shadow areas of the ground. The lighter areas of the foreground are rougher in texture to give the illusion of much more detail."

Dusk
David Band
Watercolor on 140-lb. cold-press Arches
paper
12″ × 20″

Dusk was painted with the standard wet-in-wet method for the sky. I wet the entire paper with a sponge and clean water, then covered the sky with a wash of cadmium yellow light. This was quickly followed with a mixture of alizarin crimson and Payne's gray for the clouds. Using the same colors, just a little stronger, I began to shape the clouds adding pigment gradually. This was repeated quickly while the paper was still wet so the clouds would retain the soft, feathered texture.

Soft Hazy Skies: Wet-in-Wet

The various mediums all have their own unique characteristics that give them their individuality. I find that the wet-in-wet technique is the most spontaneous and interesting when using watercolor.

Wet-in-wet is exactly that—it's wet pigment applied to a wet surface. Using a sponge with clean water, I first wet the surface, working the water into the paper evenly, being careful to avoid pooling. Because watercolor dries lighter than it goes on, it's good to strengthen your pigment. If you don't, your painting will most likely have a washed-out appearance.

Because the beauty of wet-in-wet is a soft, feathered infusion of colors, it's important to work quickly. If the paper starts to dry, hard edges will appear and defeat the purpose of wet-in-wet. Planning the sequence of colors and visualizing the end result is always the best first step. The overall result depends for the most part on the degree of wetness in the paper—for example, the wetter the surface the more it moves, so the pigments will move and blend over a larger surface. By reducing the wetness, the pigments will still blend, but they will remain in a smaller area and more definition of shapes will occur without losing the soft, feathered effect.

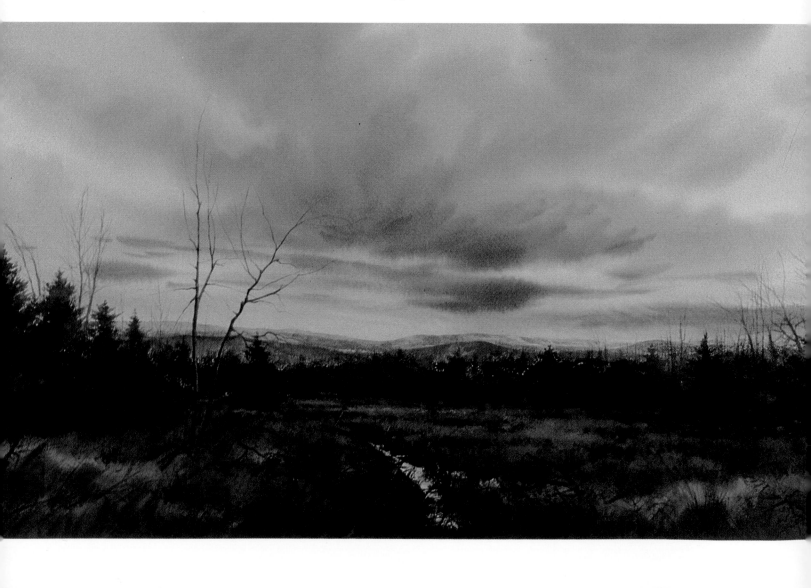

Demonstration
Wet-in-wet Sky

Step 1
Using a sponge and clean water on a 9″ × 12″ piece of 140-lb. cold-press Arches paper, I dampen the entire surface, making sure the water is evenly distributed and not allowed to pool. Next the form of the clouds is begun with cadmium yellow medium.

Step 2
Some strokes of Thalo blue strengthen and form the clouds in a few areas without totally covering the yellow.

Step 3
Because this area must be completed while the surface is wet, I work quickly to apply the next layer of color. A mixture of vermilion and alizarin crimson gives shape and volume to the clouds.

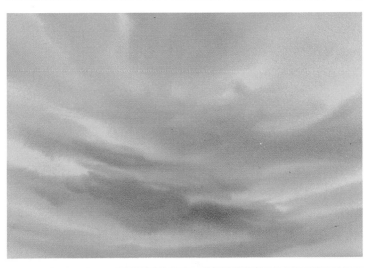

Step 4
In the final stage I assist the blending of colors by lifting and rolling the board from side to side. This can only be done if the surface is still wet, so working quickly and planning ahead are important. After the sky dries, there is a soft, blended texture.

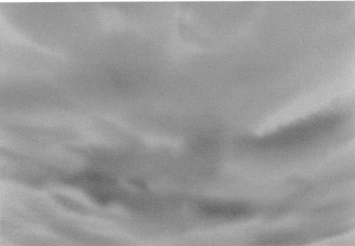

Delicate Lacy Skies: Controlled Wet-in-Wet

Controlled wet-in-wet is a way of achieving soft texture while maintaining control over the strength of the colors. Once a wet-in-wet painting has dried it cannot be worked without causing hard edges. But by completely rewetting the paper with clean water and a sponge you can add additional color to strengthen selected areas or to add more texture and definition to an area. This can be repeated as many times as necessary, but remember that the painting must be completely dry between the stages, otherwise colors will bleed. To accelerate the drying process I use an ordinary blow-dryer. To avoid hard edges, remember that the entire painting must be rewet during the working stages no matter how large or small the area being strengthened.

Demonstration

Controlled Wet-in-wet Sky

Step 1
First the outlines of the cloud formations are lightly sketched in Thalo blue. These areas will be used for the patches of blue sky.

Step 2
Making sure the paper is dry, I dampen the entire surface using a sponge with clean water. With a mixture of two parts Thalo blue and one part vermilion thinned considerably, I begin toning the clouds. Once again, this is done wet because the desired effect is soft, fluffy clouds.

Step 3
After drying with a blow dryer, the paper is dampened again, but now a mixture of alizarin crimson and Payne's gray is added to the Thalo blue and vermilion to deepen the shadowing effect.

Step 4
In the final step I continue to build up the texture and, as you can see, it is very subtle and soft. While the paper is still wet, Thalo blue is used to deepen the blue sky between the clouds.

Southwest Sunset
David Band
Watercolor on 140-lb. cold-press Arches paper
14" × 20"
Collection of Mr. and Mrs. Jim Brackett

Southwest Sunset was painted with the controlled wet-in-wet process using cadmium yellow light, vermilion, Thalo blue and alizarin crimson. With this method I was able to achieve the soft texture without losing the control needed to shape the clouds.

Hard Edge Technique

Hard edge is a style of watercolor that involves applying paint so that strokes and edges are a characteristic of the texture and the painting. This style is more closely related to the other paint mediums and is an interesting break from the soft, blended textures of the wet techniques.

Using this style I remain mindful of the basic light-to-dark principles. Any number of layers can be applied to achieve the desired colors, textures and density. Allowing each layer to dry before applying the next prevents colors from getting muddy, and interesting patterns and textures appear due to the transparent quality of watercolor.

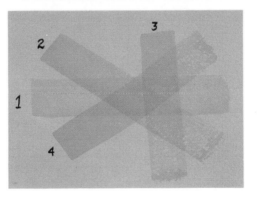

This hard edge pattern was created with transparent strokes using a ¾-inch flat wash brush. The strokes were applied in the order noted.

By using different brushes and curved overlapping strokes, unique patterns, texture and movement can be realized.

Using both curved and straight strokes strengthens and enriches textures.

This abstract landscape was produced by using straight, curved and narrow transparent strokes to create the texture.

Demonstration
Well-Defined Clouds

The hard edge technique is my method of choice for skies with strongly defined clouds or the small puffy clouds that remind me of cotton balls. Sometimes I prefer to lightly pencil in the clouds and refine them by painting in the sky as if sculpting the formations. After this stage is completed, the layered, hard edge texture can be applied to give the clouds volume and character.

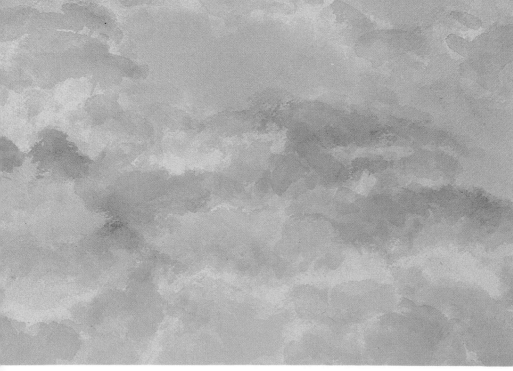

Hard edge sky
Watercolor on 140-lb. cold-press paper
9" × 12"

Step 1
Hard edge requires a dry application of paint, so I begin by using Thalo blue to paint in the sky area, leaving the paper for the cloud formations. This time I decide not to pencil in the clouds because the unpredictability of the brush can produce interesting edges for the clouds.

Step 2
With the sky areas blocked in, I use a mixture of very thin Thalo blue and Payne's gray to begin defining the clouds.

Step 3
Another layer of Thalo blue and Payne's gray is added while the first application is still semiwet, which allows a partial blending and softening of the shadows in the clouds.

Step 4
This stage is a repeat of Step 3, with slightly stronger mixtures of the same colors for the gradual deepening of shadows and cloud forms.

Step 5
In the final stage, the paper is dry, so more texture can be produced with transparent strokes. Thalo blue is added to the sky areas which strengthens the outlines of the clouds. Gradually layering transparent strokes gives the clouds their texture and character.

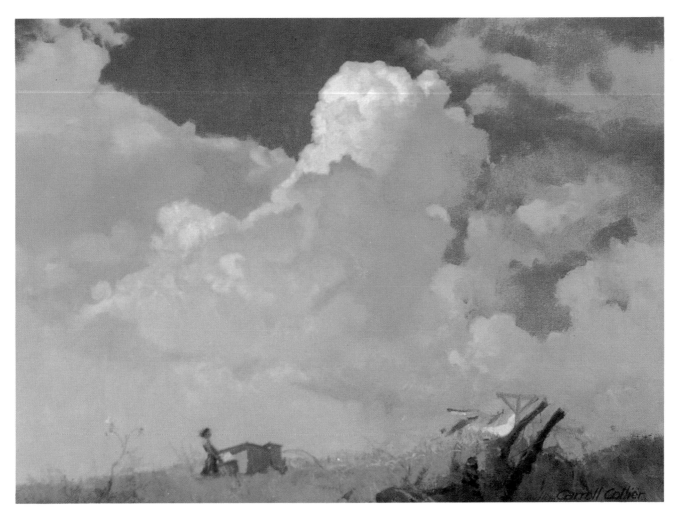

A Cloudy Day
Carroll Collier
Oil
18″ × 24″
Photo courtesy Baker Gallery,
Lubbock, Texas

Collier says, "In this painting I sought to convey the serenity I felt in the open spaces under a billowy sky. Drawing with charcoal from my photograph, I modified the cloud shapes somewhat to be more esthetically pleasing in composition and mood. I washed in the color next using turpentine as a medium. The opaque paint is then applied in the darker areas first (the blue sky and cloud shadows) paying close attention to shapes and using a fairly smooth texture. Thicker paint is used on the lighter areas and the thickest is usually on the lightest. Cloud texture is conveyed by the accurate depiction of the subtle range of color and value."

Demonstration
Layered Shapes

Another approach to the hard edge technique with watercolor is to build the sky with layers of light to dark strokes and shapes. In the *Sunset* demonstration I loosely painted in the cloud shapes with the lightest values first. With each additional stage I intensified the color with layers of the same value, leaving the light areas to give shape and texture to the overall sky area. With this method a limited palette can be very effective. Remaining patient and keeping the washes light are the keys to developing the texture with this technique.

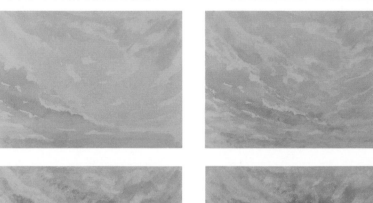

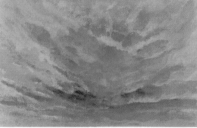

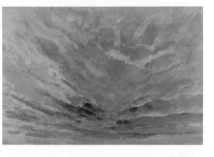

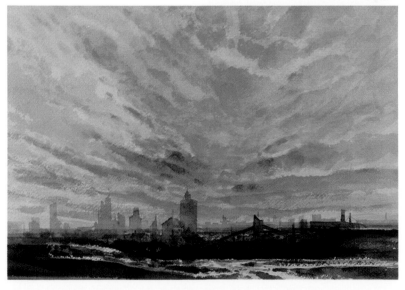

Sunset
David Band
Watercolor on 140-lb. cold-press paper
9″ × 12″

Step 1
Sunset is an exercise in perspective and hard edge watercolor. The sky is developed loosely at first with bold strokes of cadmium yellow and vermilion that are allowed to blend and dry with both soft- and hard-edged areas.

Step 2
In this next stage the colors are strengthened slightly and the strokes are not as broad. By this time the paper has dried and more hard edges are appearing.

Step 3
As the background develops, patience is the key. Darker colors are introduced with more controlled and deliberate strokes. Less water is used and alizarin crimson is added sparingly to the vermilion and cadmium yellow.

Step 4
This stage shows a gradual buildup of texture with smaller dry strokes and just a little more alizarin crimson for color and shadows.

Step 5
A thinned mixture of vermilion and alizarin crimson adds texture with transparent strokes throughout the cloud forms. Particular attention is placed on the soft mass directly overhead.

Step 6
The buildings and foreground are painted with a mixture of alizarin crimson, burnt sienna, Payne's gray and vermilion.

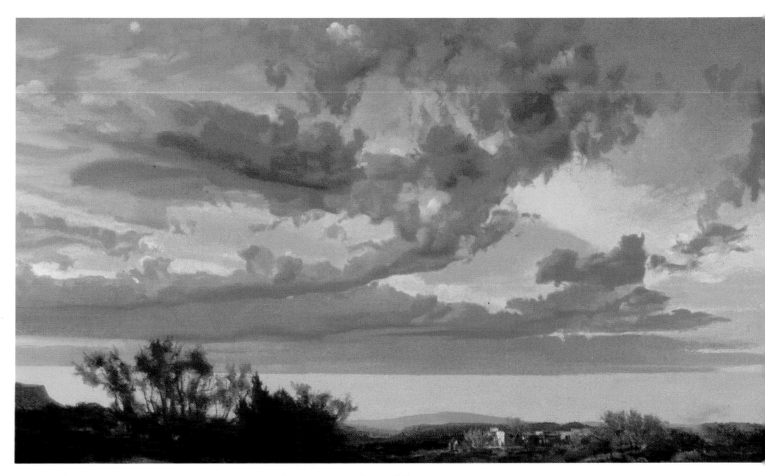

A Late Afternoon Sky
Carroll Collier
Oil
24″ × 40″
Photo courtesy Baker Gallery,
Lubbock, Texas

Here we have layer upon layer of clouds. The layering in the painting is not primarily a layering of paint but a gradation in value and color while painting in the shapes of the clouds. The distant clouds are smooth, allowing darker, more textured upper clouds to come forward, thus giving the effect of a third dimension.

Motion and Atmosphere: Combined Techniques

To emphasize motion and atmosphere in a sky, the interaction of wet-in-wet and hard edge techniques works perfectly for producing action and strong textures. First use wet-in-wet to develop the background of the sky, then work over the surface before it is completely dry to get "soft" hard edges. Continue to work during the drying process to achieve a wide range of edges and textures in the cloud formations. With this approach, the addition of rain can be done either hard edge or wet.

With watercolor there are many ways to create interest and texture in skies. Rain and light are two of the most interesting textures and can be achieved with simple techniques.

Rain. When you're using a wet-in-wet technique, adding rain is the final step. For this technique to be effective the paper must still be damp for the soft edge effect. Once the clouds have been put in over the wet background, use a wide, flat brush or sponge to draw the pigment from the wet cloud in a downward motion into the wet sky.

The same process is used with the hard edge technique, but the brush is dampened with clean water to draw the pigment from the clouds using the same downward motion. The results will be a hard edge rain because you're pulling the pigment over a dry surface.

Sand Road, San Patricio
David Band
Watercolor
12" × 19"

This painting is the result of combining hard edge and wet-in-wet techniques to create movement and strong textures in the clouds. Combining the two is useful for capturing the varied textures often found in the expansive skies of the Southwest.

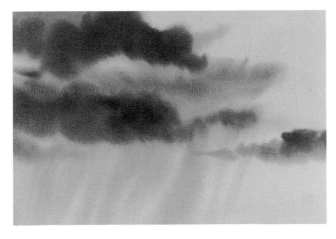

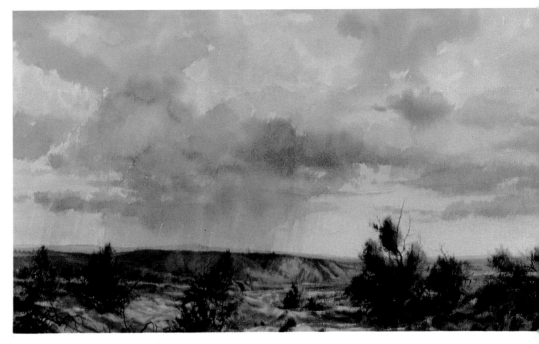

Wet-in-wet rain texture

The texture of rain can add interest to a sky and there are several effective techniques for this in watercolor. The wet approach, shown above, is done quickly by drawing the wet color in a downward motion from the bottom of the clouds with a wet brush or sponge.

Dry approach to rain texture

A slightly different effect can be achieved on a dry surface. When the sky is completely dry, a wash brush or sponge can be used to loosen the pigment in the bottom of the clouds and draw it out with the same downward motion. This produces a sharper, more distinct rain texture than the wet-in-wet approach.

Light Textures. Creating a sense of light offers much variety because you can make it subtle or obvious, bright and hard or soft and hazy.

A break in the clouds can suggest light coming through and a spot of light on the area below completes the suggestion. Or you can leave little to the imagination and actually show the light rays and the direction they travel. A method I like to use for showing light rays involves lifting the color from the clouds with a stiff bristle brush, blotting the color, and repeating this as many times as necessary to achieve the texture of the light rays. Keep in mind that the surface must be dry.

Desert Drama
David Band
Watercolor
14" × 20"

Desert Drama has the type of sky that is very common in the Southwest where small pockets of disturbance emerge quickly and move rapidly. It's not uncommon for the sun to be shining on one side of the road and rain to be falling on the other. There is usually lots of movement giving the clouds varying textures with crisp breaks and patches of bright light. To convey these rapidly changing textures in the sky, I chose the dry, hard-edge approach for the rain and clouds.

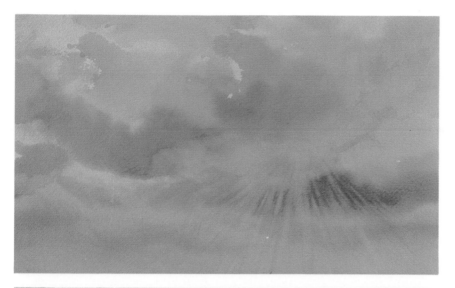

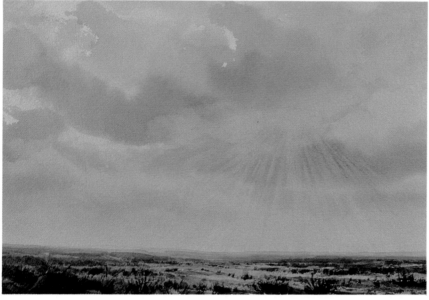

Light Rays
David Band
Watercolor on 140-lb. cold-press Arches paper
9" × 12"

Step 1
The texture produced by light breaking through clouds can be suggested by spots of light on the landscape, as in *Desert Drama* (see previous page), or lifted out by scrubbing as in this example. This sky is painted both wet and hard edge using Thalo blue and Payne's gray. When it is completely dry I use a stiff acrylic brush to scrub and lift the paint with clean water.

Step 2
The scrub-and-lift technique works with any colors, but the best results are realized with darker colors like those found in sunsets or stormy skies. To accentuate the effect and texture of the light rays I use yellow-green in the landscape for the areas receiving the light.

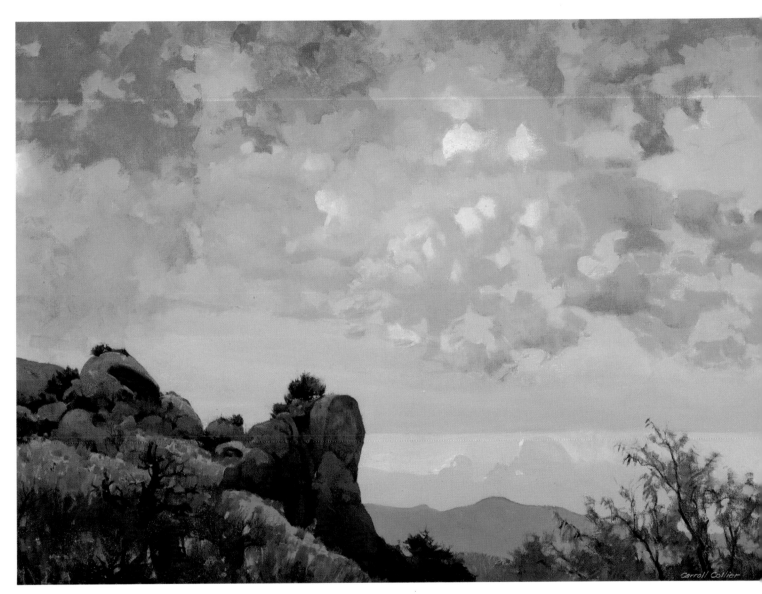

Sunrise in the West
Carroll Collier
Oil on canvas
30″ × 40″
Photo courtesy Baker Gallery,
Lubbock, Texas

Because the sky is continually changing, it provides an endless spectrum of colors, textures and shapes. What I've touched on in this chapter represents a very small portion. In Carroll Collier's oil painting *Sunrise in the West* he provides a wonderful example of texture and patterns of light found in a developing sunrise. Collier states that mood and balance were his objectives in this painting.

Collier says that as he was painting, the clouds were fascinating, but, as happens too often, the objects on the ground did not work well with the composition of the sky. So, drawing on a photo with just the right outcropping of rock, he was able to complete his work with the proper counterbalance for the focal point in the sky.

Whether the sky is used as background to illuminate a subject or as the subject itself, it offers us wonderful textures, colors, light and moods.

Because the light on the clouds created such a strong focal point, Collier felt that a proper counterbalance was necessary. For this he carefully selected just the right outcropping of rock in the foreground.

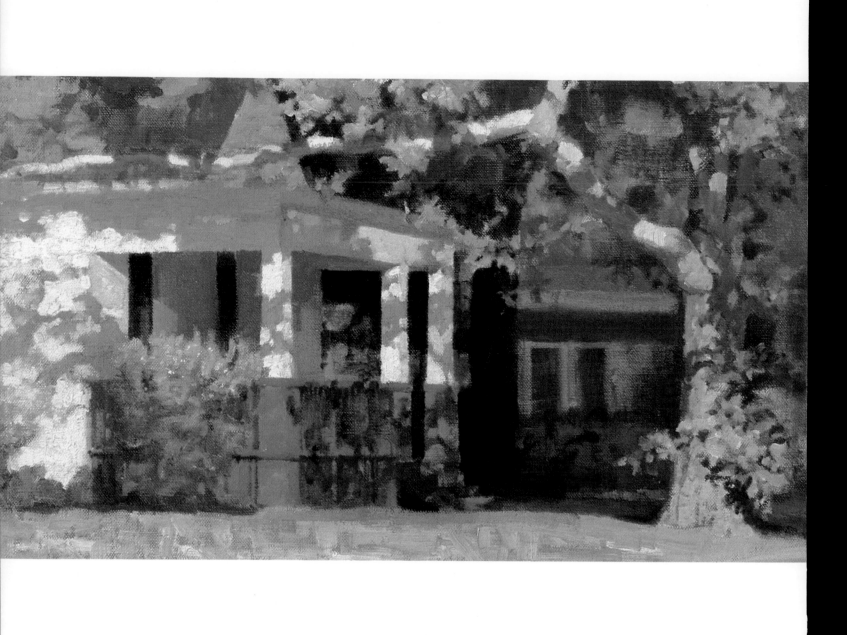

Chapter Three
Trees

Spring Morning
Carroll Collier
Oil on canvas
12" × 18½"
Photo courtesy Baker
Gallery, Lubbock, Texas

Here is an interesting
pattern of light reflected
from a sycamore tree.
Collier intentionally sim-
plified the masses giving
a pleasant overall im-
pression. The thick paint
in the lighter areas gives
the impression of glaring
light, too strong to see
detail within.

Because trees and foliage present so many interesting textures and patterns it's best to work outdoors where you can actually touch them and examine them from all angles and distances. Photographs can be very useful, but there is no substitute for that direct contact to gain an in-depth understanding of these textures and how they develop.

No two trees are identical; each is unique in texture and character. Some trees begin to branch high on the trunk and some low, but they all seem to be reaching for the sun.

Bark presents an enormous variety of textures, from the heavy, deeply etched white willow, to the soft shaggy northern white cedar. Although there are varieties of trees belonging to the same family, it doesn't necessarily mean that the bark and textures will be the same. For example, the strong vertical grooves found in the blue, white and green ash contrast dramatically with the soft horizontal eruptions over a fairly smooth surface found on the American mountain ash.

Interpreting Texture

If a tree is the subject of my painting then I will make the details and bark textures my primary focus. But what about when trees are not so close, when the detailed textures are difficult to see and impossible to paint; how can they be interpreted?

Direct contact and experience with your subject is vital when it comes to making decisions regarding how far to go with the detailed textures in your subject. The selection of painting surface and medium is the first decision that will affect your subject and your style. In *Wilderness Walk* by John C. Pellew, the materials and style assist and enhance the interpretation. By using very little water and lightly brushing in the trees, the paper's surface supplies the bark texture and highlights simultaneously. The clean, crisp feeling is carried throughout the foliage, figures and rocky foreground with the same free and spontaneous strokes.

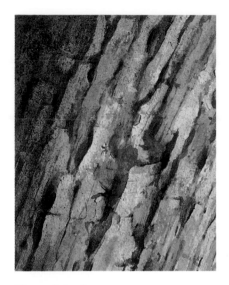

Blue ash bark
Watercolor

The bark of the blue ash, like the white and green ash, has strong vertical grooves.

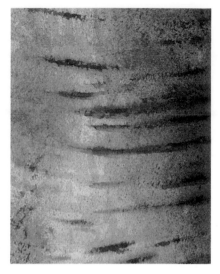

Mountain ash bark
Watercolor

The mountain ash has a fairly smooth surface with soft horizontal eruptions.

Wilderness Walk
John C. Pellew
Watercolor
18″ × 24″

Using a dry brush and the rough surface of the paper, Pellew is able to convey the textural qualities of the trees and foliage.

Heavily Textured Bark

There are many different ways to achieve varied textures of tree bark. A quick method for painting trees with rough, heavily textured bark in watercolor is to use a dry-brush application. It's a simple, two-step method. First, rough in the trees and second, use a clear water wash to bring out the color and give volume to the tree. Whatever colors the tree should have will be included in the initial dry application and the wash will cause them to break out and blend appropriately.

The quick two-step application can be carried further with a third step of additional shading and color if desired, and because the wash has a tendency to soften the rough texture, it can be strengthened with an additional dry-brush application once the wash has dried.

This same technique works equally well for rough texture at a distance and for background trees.

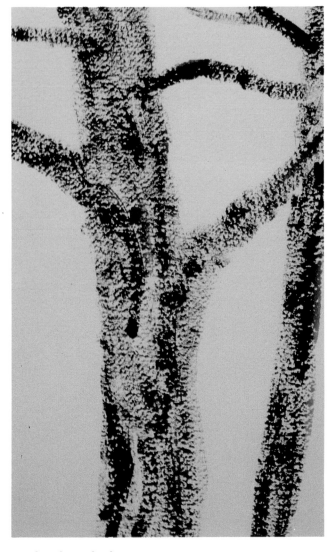

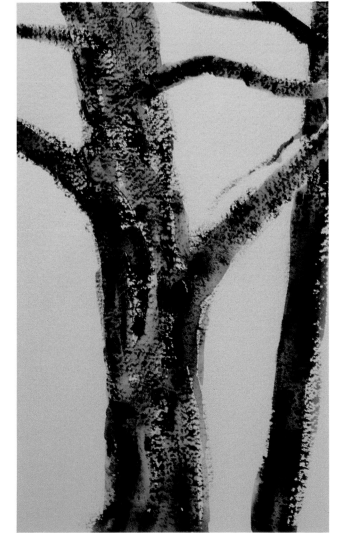

Dry brush method
Watercolor on 140-lb. rough paper

Step 1
With yellow ochre, burnt sienna and Payne's gray the basic shapes of the trees are painted in dry by lightly dragging the brush over the paper's rough surface.

Step 2
After the paint has dried, a clear water wash is applied over the trees. This causes some of the colors to blend and gives volume and texture to the tree.

During this process of two, three or even more applications, the painting can have several finished appearances. It's entirely up to you which step has the amount of texture and character you desire for the finished painting. In *Bare Trees* I feel that the second step could have been a stopping point if I had wanted the trees to blend with the overall texture of the painting. By continuing to strengthen the texture of the trees they were brought forward to make a stronger statement.

Bare Trees
David Band
Watercolor on 140-lb. rough paper
9″ × 6″

Step 1
Background, trees and foreground are all roughed in with burnt sienna, Payne's gray and thinned Thalo blue.

Step 2
Light washes of Thalo blue and clear water are applied over the entire painting to soften the overall textures.

Step 3
At this point the background is textured by spreading the bristles of a no. 8 round sable using downward vertical strokes with a combination of Thalo blue and Hooker's green. This is followed by a light Thalo blue wash over the trees and grass to complete the softening of the textures.

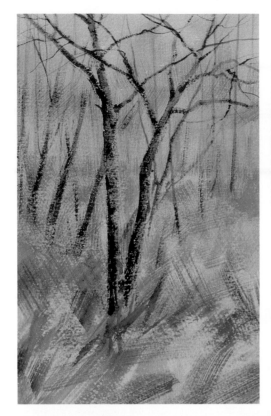

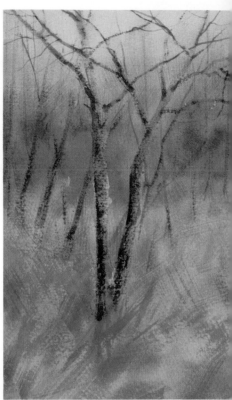

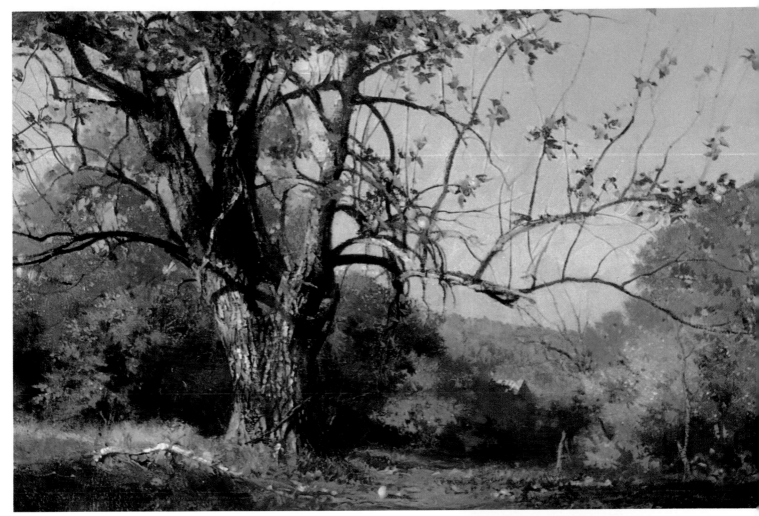

Decaying Trees

When we think of texture in relation to trees, it is the foliage and grooved bark that first come to mind. But some of the richest sources of fascinating and unusual textures are dead trees, where the bark has fallen off, exposing the smooth, dry wood with its cracks and holes.

Likewise, decaying sections of living trees present a variety of textures and when included in the painting can add interest and contrast. In the small watercolor at right, a close examination of the rotting tree interior is made. The cracks, insect holes and peeling bark provide unusual patterns and textures.

The Old Tree
Carroll Collier
Oil on canvas
20″ × 30″
Photo courtesy Baker Gallery,
Lubbock, Texas

Collier says ''This is a very old bois d'arc tree, fascinating shape. The texture of the trunk was achieved by dragging paint on a bristle brush over a dried texture, as well as painting the shadow and light area of the bark. I usually paint on a mid-value with thin paint, then paint in the darker part and then the lighter.''

Decaying Bark
Watercolor on 140-lb. rough paper

Rotting interior, insect holes, cracks and peeling bark provide a bountiful source of textural possibilities.

Demonstration
Suggesting Decay

In this painting I wanted to use the decaying section of a pecan tree to bring the viewer into the painting. By suggesting the decay with minimal detail it became part of the tree rather than the subject of the painting. Sometimes it becomes difficult to control the desire to overemphasize the unique or special elements in our work, like the decaying section in a tree. But many times it benefits the whole painting to eliminate some of the detail we see. The decision of "how much detail?" is part of how we choose to interpret the scene. The more familiar you are with the subject, the easier those decisions become.

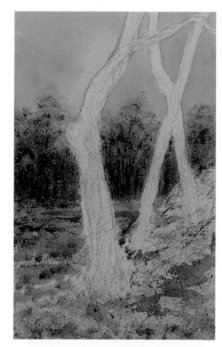

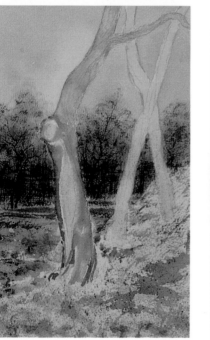

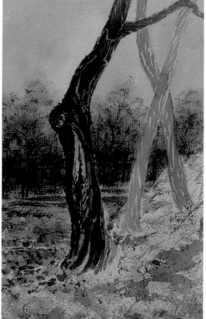

Spring
David Band
Watercolor on 140-lb. cold-press paper
9½" × 6"

Step 1
After drawing in the foreground trees in pencil, a flat wash of very thin Thalo blue and Payne's gray is applied to the background and sky. Spotting of the midground and foreground is done with yellow ochre, burnt sienna and Hooker's green.

Step 2
Additional texture and definition are applied to the background and foreground by splattering with burnt sienna, alizarin crimson and yellow ochre.

Step 3
A wash of yellow ochre and vermilion is applied to the foreground trees followed by a light wash of Payne's gray to the bark areas outlining the decayed section.

Step 4
At this point a light mixture of Payne's gray and Thalo blue is used to begin texturing the tree trunks. Repeated applications are made to build up the texture. Each layer is allowed to dry before adding the next.

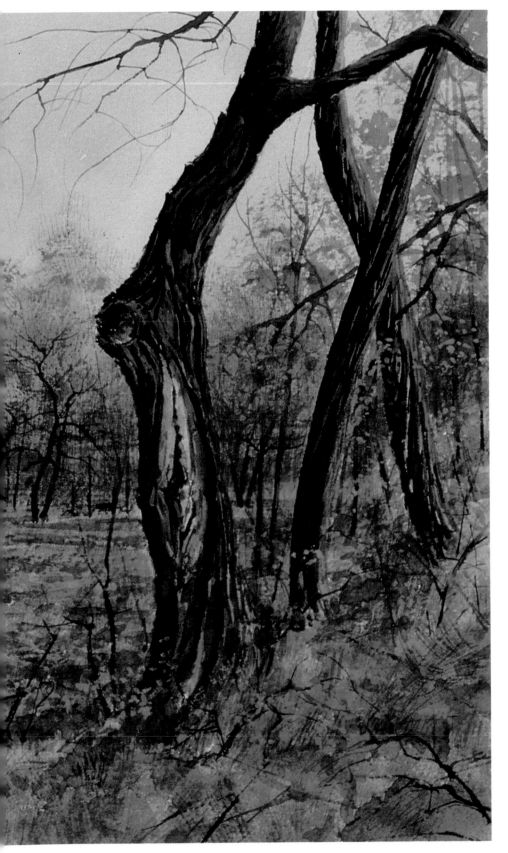

Step 5

This is where it all comes together. To pick up the highlights of the bark I use a mixture of Chinese white and burnt sienna, which gives depth to the bark. The same approach is used on the background trees, only this time I use Chinese white and yellow ochre to highlight the bark. A final application of strong Payne's gray is used to put the final details on the bark and the center of the decayed area.

Demonstration
Finding a Special Subject

Some artists prefer to do all of their work on location like the plein air painters, which is from a French term, *en plein air*, meaning in the open air. Others prefer to work entirely in their studios, from imagination, settings and photographs. Somewhere in-between are those artists who combine the best of both worlds by looking for those special places and doing a series of the spot sketches, miniature paintings and photographs for finished studio work. Carroll Collier is one of these artists.

When I ask most artists what is the first step in their work, the most common quick reply is: "My preliminary drawing" or "I block in the composition." Collier's reply is: "Finding a special subject." He then photographs it and paints a miniature on location. This makes up the first step. The second step is to compose the painting. Using two L-shaped pieces of paper, Collier places them over the photograph and moves them around until the right composition becomes apparent. He then deletes or adds objects as needed to finalize the composition. Only then is he ready to begin work on the canvas.

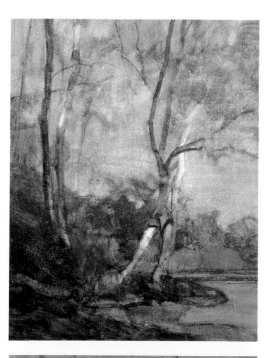

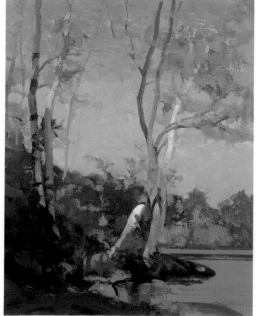

Sunlit Trees
Carroll Collier
Oil on canvas
20″ × 16″

Step 1
Using a textural white mixed with a little turpentine, the canvas is covered freely with a 2-inch background brush and then the composition is rendered in charcoal.

Step 2
Using a violet-colored turpentine wash made from a mixture of ultramarine blue and a lesser amount of cadmium red deep, Collier concentrates on developing the lights and darks. With this value pattern completed he then applies colors to each of the areas, keeping in mind that they don't have to be exact at this point.

Step 3
Collier applies heavier paint with a painting medium while modifying texture and refining colors and values. This process is made easier by the previous application of the toned turpentine wash. It is difficult to compare values and colors on a white canvas.

Step 4
Using carefully considered strokes to bring out the textures and highlights, Collier takes control. Cast shadows add that special touch which illuminates the subtle texture in the trees. He claims this is his favorite step because it is here that the painting comes to life with the completed textures, spontaneous strokes and design improvisations.

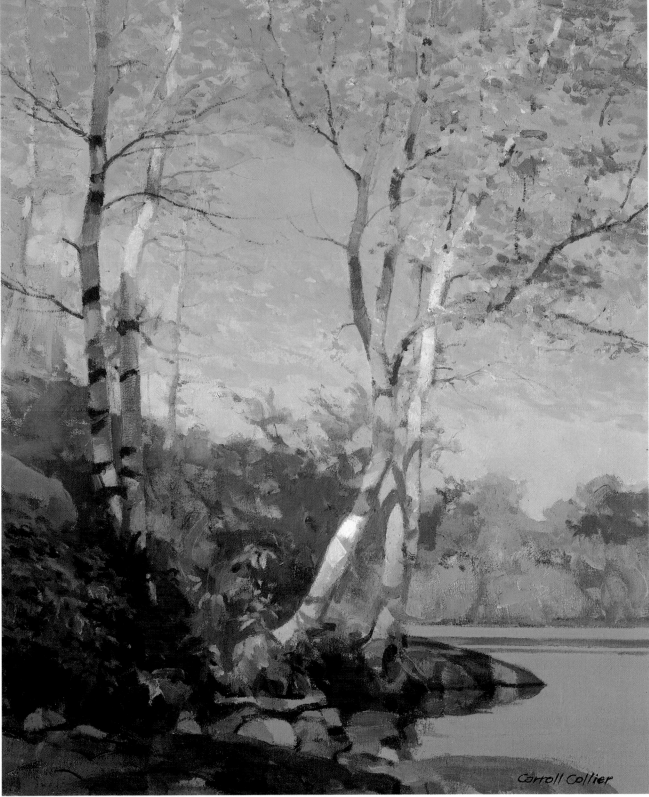

Carroll Collier

Smooth Textured Bark

The first image that comes to my mind when I think about texture in trees is rough, deeply etched bark with unusual patterns and growths. But there are many trees that have smooth or moderately raised surfaces like the birches and some species of the aspen. A closer look at these textures reveals some very interesting blends of color and surface.

Painting birch bark with watercolor can be done quickly because the white paper takes on most of the responsibility. All you have to do is select the additional colors and texture.

Birch bark
Watercolor on 140-lb. rough paper
5½" × 4"

With the wet-in-wet technique, the paper supplies the majority of texture for smooth-surfaced trees. First, wet down the section to be painted. Then drop a mixture of watered-down Payne's gray and Thalo blue into the left side of the image, allowing it to bleed softly over the wet surface. When the surface is barely moist (cool to the touch but not wet), the additional strokes of texture are applied with equal parts of diluted burnt sienna and Hooker's green. Doing this when the paper is cool to the touch ensures a soft texture to the strokes and a transparency that remains consistent with the overall texture of the bark.

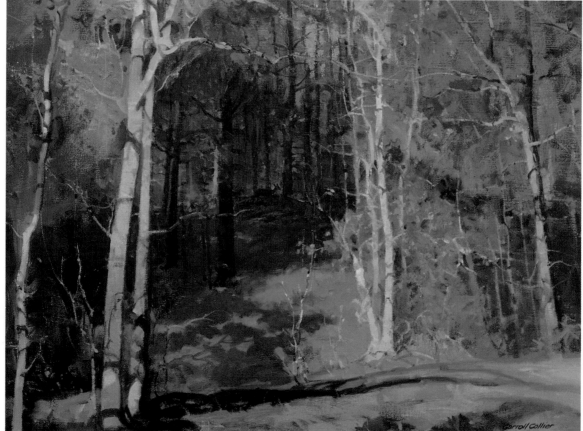

Autumn in the Woods
Carroll Collier
Oil on canvas
18" × 24"
Photo courtesy Baker Gallery,
Lubbock, Texas

Collier says, "This east Texas woods was interesting for its simplicity. I applied a medium texture by using unthinned paint on bristle brushes to rough in the whole. After letting it dry a couple of days, I used some medium in painting in the major trees, concentrating on color and value while I mixed the color, dragging the brush with paint (no medium) in some trees to allow the underpainting to show its texture."

Smooth Bark From a Distance

The more interesting textures of the smoother barks can be seen better the closer you are to the tree. There are so many subtle blends of colors, tones and lines. Moving away, details begin to merge, which could present a bland, unexciting subject. To add interest a more painterly approach seems to work well.

With transparent watercolor, the paper supplies a large portion of the texture, but with opaque watercolor the paint and strokes ultimately provide the texture.

Kent Day Coes used opaque watercolor to create the texture of smooth bark as seen at a distance in *Winter Wood* (above). The foliage, trees, grass highlights, and shadows in the snow are all enriched by Coes's use of opaques.

Winter Wood
Kent Day Coes
Watercolor on 300-lb. cold-press paper
21″ × 29″

Throughout the painting the use of opaques enriches the texture by strengthening the shadows and highlights.

Demonstration

Layering Texture With Opaque Watercolor

Whenever I choose to use opaque watercolor for my finished paintings, I find it works best to start with a transparent base and then gradually develop the opaque textures as needed. In *Six Birches* I used opaques for the trees and a few highlights and left the transparent watercolor for the remainder of the painting.

Six Birches
David Band
Watercolor on 140-lb. rough paper
9½″ × 6″

Step 1

The trees are lightly drawn in with pencil, then a light wash of diluted Payne's gray is applied to the trunks for the formation of a textured base.

Step 2

The birches are blocked in by painting the background foliage with strong Payne's gray.

Step 3

The mid- and foreground grasses are put in with mixtures of burnt sienna, yellow ochre and small amounts of alizarin crimson.

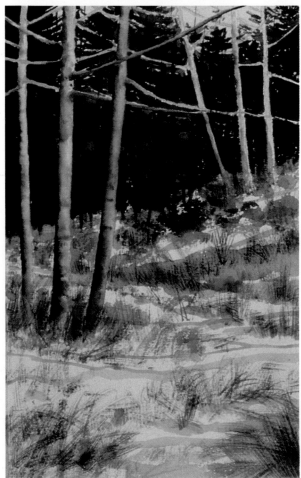

Step 4

With this completed, a series of opaque washes using Chinese white, yellow ochre, and a touch of Payne's gray are applied to texture and shape the trees. Final sharp details of lines and holes are added with Payne's gray straight from the tube. Because the washes are opaque, they can be applied light over dark and dark over light as many times as needed to achieve the desired texture.

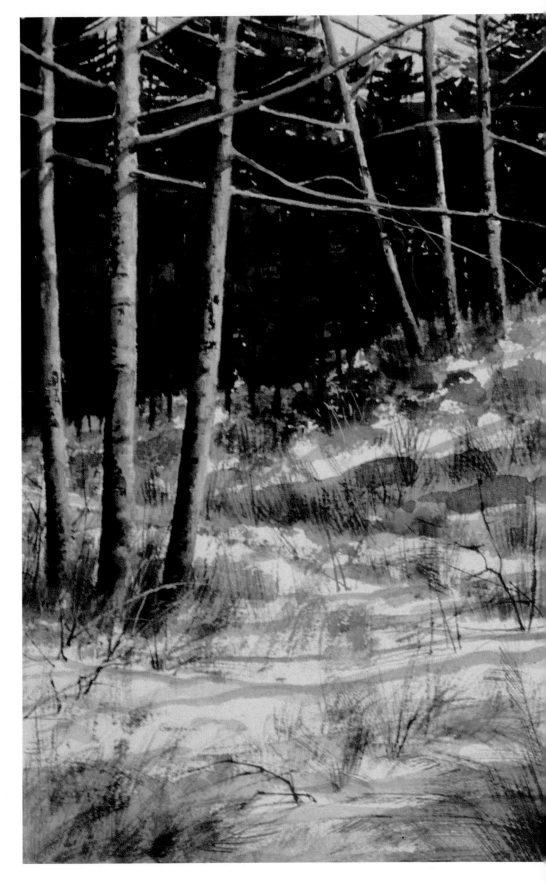

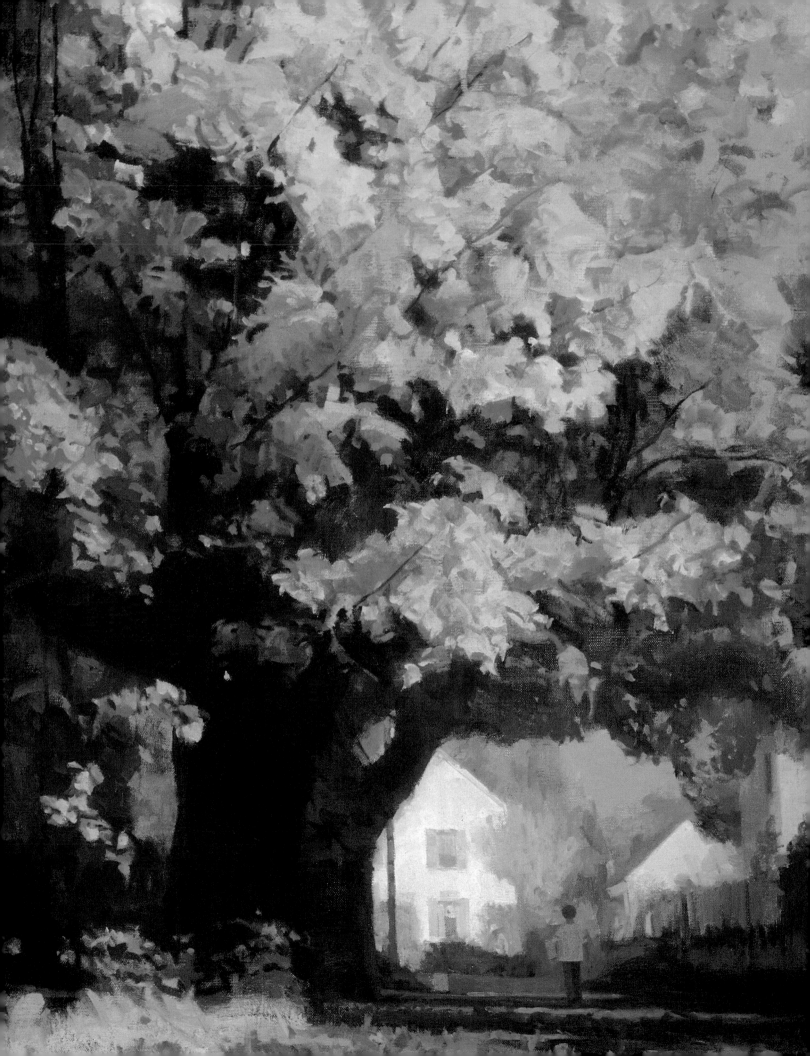

Chapter Four
Foliage

Autumn Leaves
Carroll Collier
Oil on canvas
30″ × 24″
Photo courtesy Baker
Gallery, Lubbock, Texas

Using a striking combination of related shapes, values and textures, Collier kept the leaf sections on the major tree simple, making changes in color and value on heavy texture, but not defining each leaf.

Foliage comes in many shapes and colors which produce wonderful and distinct patterns of texture. Some trees produce leaves and others, like the spruce, pine and fir, have bunches of needles. No matter which, they all provide varying and interesting textures up close or at a distance.

In addition to coming in many shapes and sizes, leaves also have a variety of textures and surfaces from a high gloss to a flat, dull finish. These factors along with the changing seasons and time of day influence greatly how we see and interpret the structure and mass of foliage texture. The different kinds of blossoms, nuts, berries and cones must not be overlooked as part of foliage texture.

Seasonal Foliage

It's safe to say that autumn is one of the most colorful and beautiful times of the year. The changing of the leaves is truly spectacular with the brilliant yellows, greens, reds and oranges. No matter what medium is used to paint this event, the results can be very satisfying.

In Carroll Collier's oil painting *At Stone Mountain* (below), his understanding of the subject and the marriage of surface, medium and style have all come together in a well-developed composition. The softly textured, brightly colored fo-liage against the soft blue hues of the distant graystone hills and the movement of the cast shadows put the final touches to Collier's work, reflecting the charm and serenity of the subject.

John C. Pellew's watercolor *Farrington's Pines* (right) is a wonderful example of using rough watercolor paper to assist in providing just the right texture for a subject. Pellew is a great believer in simplicity and with a pallet of burnt sienna, phthalo blue and the rough paper, he is able to capture the subtle textures and the light flickering through the foliage.

In the two watercolor demonstrations that follow, *October* and *Autumn Light*, I used two different watercolor techniques to produce the same textural effect. *October* is painted in a traditional light-to-dark method with a large portion of the foliage area being handled with several layers of substantially thinned pigments to preserve the sunlit quality of the foliage. The transparent qualities of the colors create the textural character of the completed work. In *Autumn Light* the rough surface of the paper produces the final texture.

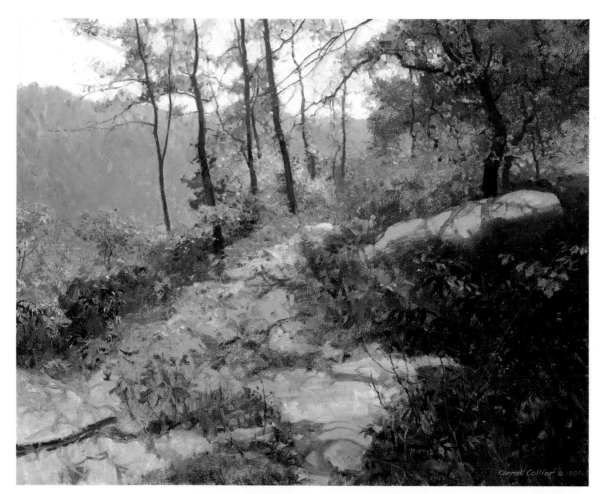

At Stone Mountain
Carroll Collier
Oil on canvas
24" × 30"
Photo courtesy Baker Gallery, Lubbock, Texas

The softly textured, brightly colored fo-liage against the soft blue hues of the graystone hills are instrumental in setting the mood for Collier's work.

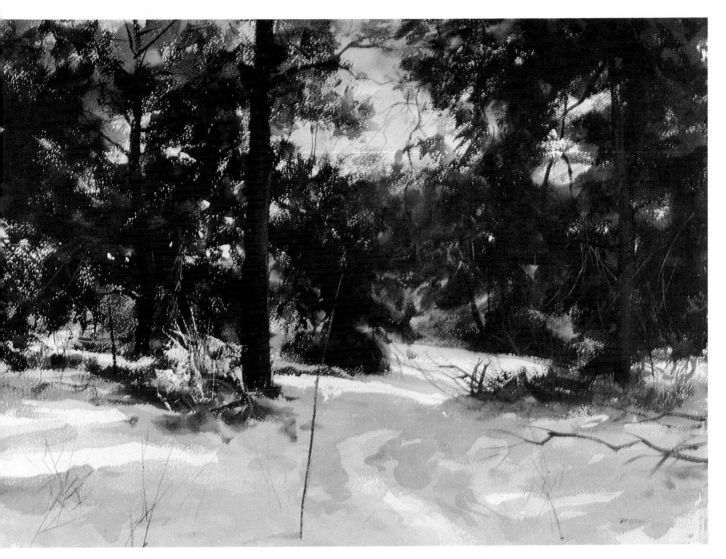

Farrington's Pines
John C. Pellew
Watercolor on paper
22" × 30"

Detail of *Farrington's Pines*

In this close-up it's easy to see just how the rough paper and free painting style have combined to provide the perfect texture for the subject.

Demonstration
Layering Transparent Texture

In this demonstration, because the texture of the foliage is achieved with layering and transparency, quality papers of most weights and textures work well. I chose 140-lb. cold-press watercolor paper with its moderately textured surface and excellent color retention. To keep the soft rolling edges of the overlapping foliage, I used round sable brushes of several sizes along with a fine detail brush and my faithful toothbrush for the final splattering texture, which gives the effect of the small shadows or "holes" that are characteristic of autumn foliage.

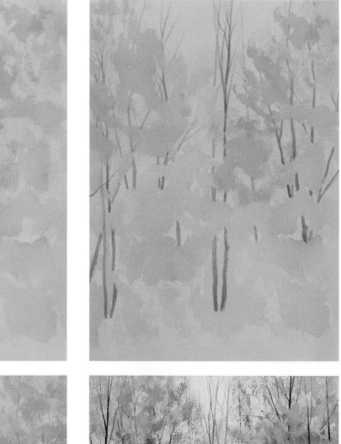

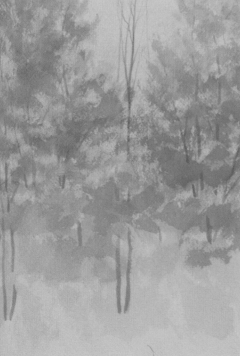

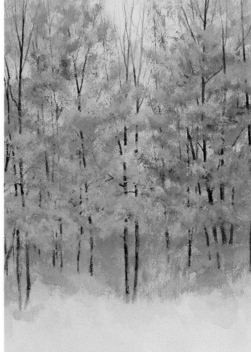

October
David Band
Watercolor on 140-lb. cold-press paper
12" × 9"

Step 1
Using cadmium yellow medium and a touch of Hooker's green, the basic background shapes of the foliage are painted in lightly with a no. 6 round sable.

Step 2
The trees are put in with a thinned mixture of burnt sienna and Payne's gray.

Step 3
With a thinned mixture of burnt sienna and vermilion, various areas of the foliage are enhanced, with care taken not to cover all of the previous colors.

Step 4
For additional texture, a mixture of burnt sienna and Hooker's green is used to splatter the foliage along with a little cadmium red mixed with burnt sienna for a few selected areas of the foliage, still allowing the previous layers to peek through. To strengthen the composition, a few more trees are added with Payne's gray and burnt sienna.

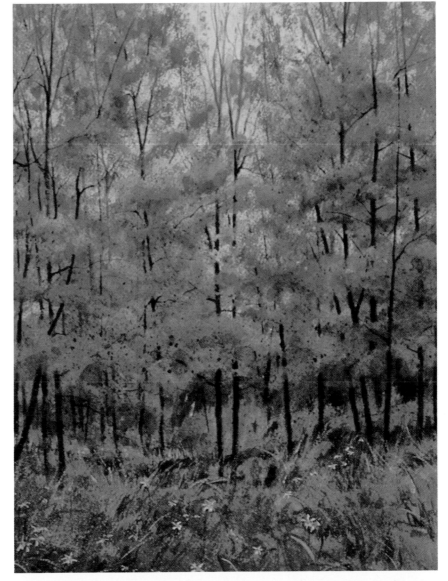

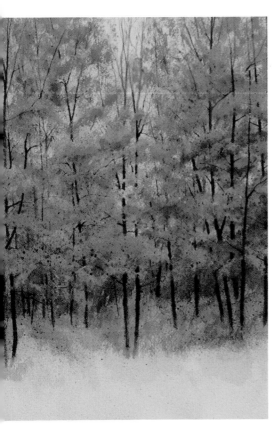

Step 5

Smaller strokes of cadmium orange and burnt sienna are used to texture the larger masses. Payne's gray is used to splatter the bottom half of the foliage and put the finishing touches to the trees.

Step 6

To complete the painting and secure a consistency and harmony, the same method of layering the foliage is used for the grass. With a base layer of yellow ochre and Hooker's green, each layer is intensified until the desired textures are achieved.

Detail (right)

A closer look at the layering reveals the texture and depth of the foliage as well as the importance of the light supplied by the first layer of background colors. That's why I stress not covering too much of the initial layers while building the texture.

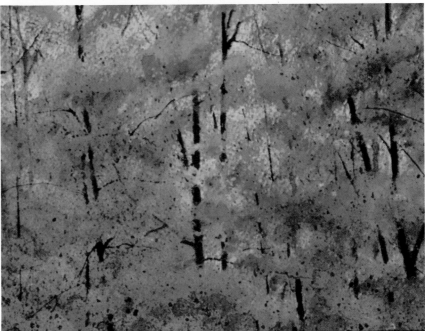

Demonstration
Using the Paper's Texture

The keys to this texture are light pressure, almost dry pigment and allowing background lights to peek through the strokes. If too much water is used, the paint will flow into the high and low areas of the paper defeating the desired textural effect. So keep it dry!

The foliage is not painted in solidly in order to leave areas for shadows and texture when the final touches are put in. Before the final details, the foreground grass and trees are painted to pull the composition together. Opaque watercolor is the choice for the foreground trees both right and left.

With this technique, both the opaque and transparent areas receive the texture equally well. The rough surface has done its job by giving light and shadow an equal quality.

Autumn Light
David Band
Watercolor on 140-lb. rough paper
6″ × 9″

Step 1
After laying in a flat, clear sky of thinned Thalo blue, loosely painted sections of background foliage are put in using yellow-green; they are allowed to blend randomly.

Step 2
Using a thinned layer of burnt sienna, additional foliage is begun using strokes in a circular motion and with very little water. The paper's rough surface begins to pick up spots of pigment.

Step 3
After the surface is dry, the process is continued with the next layer of foliage using burnt sienna and vermilion in the same circular motions with very little pressure.

Step 4

Now that the foliage is almost complete, the narrow tree trunks and branches are put in by lifting and scrubbing the paint with clean water and a stiff bristle brush. This may require several tries to get the area light enough.

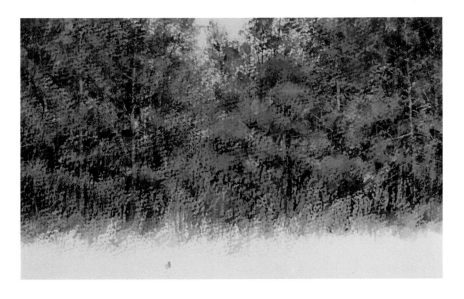

Step 5

Opaque mixtures of Chinese white and yellow-green are used to paint the foliage on the right and left foreground trees. The trunks are finished with Payne's gray, Thalo blue and Chinese white. To maintain a consistency of texture the opaques are applied with light strokes and very little water in the same manner as the background foliage. The final details, including the foreground grass, are added.

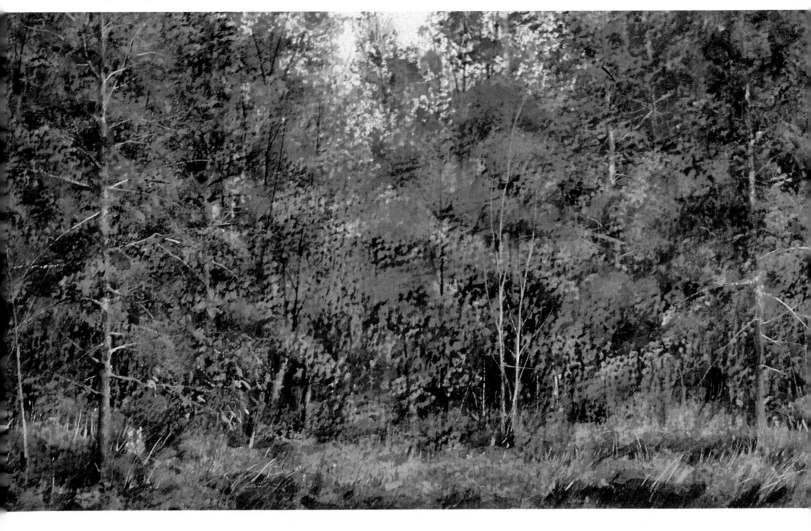

Demonstration
Painting Soft or Hazy Foliage

How about those misty or hazy mornings that nature lovers are familiar with, the kind where the sun is just beginning to remove the chill from the air?

Everything in the distance looks like a wet watercolor; large masses seem to blend. It's hard to tell where one tree begins and another ends. Sometimes the haze appears as a mist hanging just above the surface of a pond and other times it completely envelops the landscape. No matter how you see it, it produces a soft mystical quality to the foliage and landscape, perfect for giving a painting a delicate and peaceful mood. Because of the beautiful blending and the softness that can be achieved with wet-in-wet watercolor, it seems to be the natural choice for this effect.

In *Hunters* I used the soft foliage produced with the wet-in-wet technique to convey the peaceful-

ness of the early morning. When the painting dried, it provided an excellent background for the bare trees and figures.

To paint soft-textured foliage, as

with any wet-in-wet subject, it's important to plan each step carefully before beginning because once the paper starts to dry, the hard edges begin to appear.

Hunters
David Band
Watercolor on 140-lb. cold-press paper
6″ × 9″

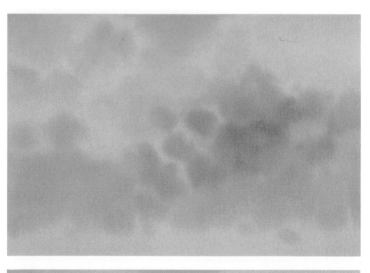

Step 1
After the entire surface is wet evenly with clean water and a sponge, Thalo blue is washed in for the sky and a thinned alizarin crimson to tone the clouds. If the paper is too wet, the colors will run together, losing definition. Large drops of yellow ochre and yellow-green are dropped into the wet paper to begin the foliage textures.

Step 2
Cadmium yellow and burnt sienna are dropped into the yellow ochre and yellow-green to continue building the soft foliage texture.

Step 3
While they are soaking in, cadmium yellow is dropped in the same way, then burnt sienna and Hooker's green.

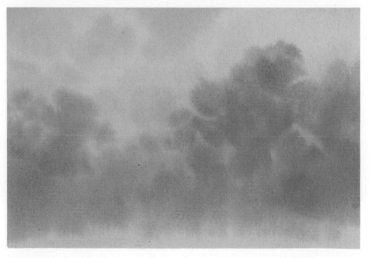

Step 4

Hooker's green and Payne's gray are used together at the base of the foliage to add stronger texture and give more volume. To maintain a soft texture the grass is painted wet-in-wet with yellow-green for the base color and burnt sienna blended in for additional color. This is all done quickly while the paper is still wet.

Step 5

The final texture is painted while the paper is still wet using Payne's gray and Hooker's green in the foliage and foreground grass. Once the paper has dried, the hazy background foliage provides an excellent backdrop for the figures and bare trees.

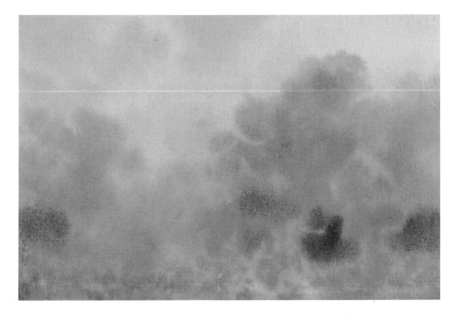

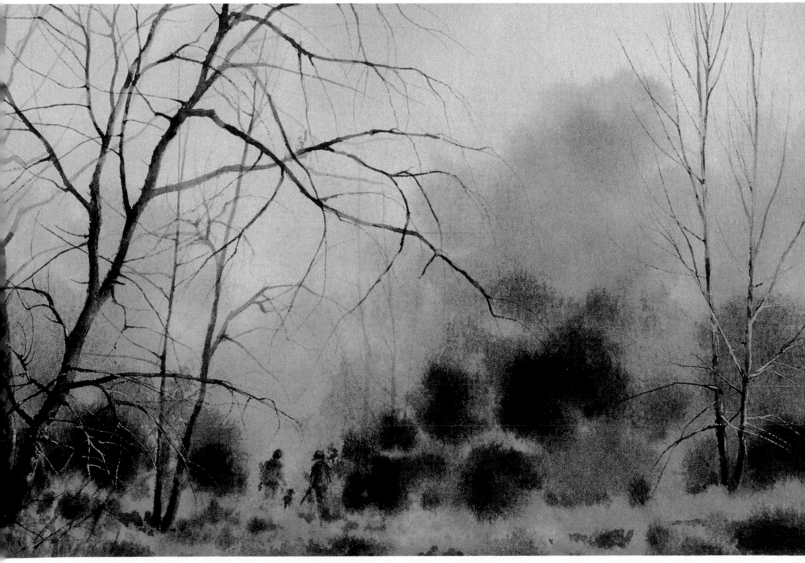

Special Watercolor Techniques for Foliage

There are a number of techniques unique to watercolor that will help you develop foliage textures.

Blotting. Blotting is a good exercise to develop your creativity and ability to see abstract patterns. Any absorbent material (paper towels, sponges) will work just fine. The paper surface can vary in texture as well, but I prefer the hot-press, slick surfaces for this technique. The first thing is to have some idea or subject in mind and use colors appropriately.

For foliage, cover a piece of hot-press watercolor board with an ample amount of yellow-green and Hooker's green. While it is still wet, use a crumpled up paper towel to pick up the color. By pressing the paper towel onto the surface with enough pressure to absorb the paint, interesting patterns are created by the texture of the paper towel. After the blotting is completed allow the board to dry. Then let your imagination take over.

In these examples, the texture of the paper towel left intricate and lacey patterns, reminding me of a close-up of leaves growing from the green stalks of a plant or vegetable. With this in mind I proceeded to bring out the shapes. With mixtures of Hooker's green, yellow-green and Thalo blue, I began to look for and paint in the shadows and textures around the stalks and leaves. With each layer the light, lacey patterns began to emerge as identifiable foliage. This technique can be used for any number of textures including fabric, flowers or even frost on a window.

Blotting texture
Watercolor on hot-press Arches board
4" × 6"

Step 1
A mixture of Hooker's green and yellow-green is applied loosely to the entire surface. Before the paint dries, a crumpled paper towel is used to press patterns into the paint and blot the color, leaving light, lacy textures.

Step 2
More Hooker's green is applied in certain areas and again blotted with a crumpled paper towel.

Step 3
Once the surface has dried, the leaflike patterns are brought out and defined by using Hooker's green, yellow-green and Thalo blue to paint the shadows and texture.

Splattering. Splattering is a very common method for developing texture. You'll see it used often in this book for describing texture in any number of subjects.

For painting leaves up close or at a distance, sparse or dense, splatter is an excellent technique. The size of the splatter can be controlled by the amount of water or medium used to thin the paint and the type of brush or tool you use. I prefer a toothbrush because the texture can be controlled much easier than with a brush.

Producing the texture can be done in several ways. Some artists prefer to tape the brush against another brush, pencil or firm object like the hand. This does produce interesting texture but is difficult to control. Another method is to flick the bristles against the tip of the finger or to pull the bristles back with the finger and release it onto the paper in the direction the splatter is supposed to go. With a toothbrush there is more directional control as well as control of consistency.

To keep the texture sharp and distinct, make sure each layer is dry before starting the next one, otherwise some of the splatter will run and become blotchy. Although, an initial texture of both blotchy and defined foliage is sometimes preferred to add a little character.

Splatter texture
Watercolor on 140-lb. cold-press Arches paper
6" × 9"

Step 1
After the sky has dried, the first layer of texture is applied using a toothbrush and a mixture of Hooker's green and yellow ochre. When this has dried a second layer with more water is applied to get areas of blotchy texture.

Step 2
On a dry surface, a layer of fine texture is applied using burnt sienna and Hooker's green with enough water to make the paint flow into an evenly textured splatter.

Step 3
The branches are painted in with burnt sienna, and another layer of fine splatter is applied to the branch ends for additional light texturing.

Lifting and Scrubbing. Lifting or scrubbing to create texture is another watercolor method that works very well for adding highlights or lightening a dark area. By planning ahead and using the lifting process in a gentle manner with water and a bristle brush, you can keep the paper fresh. If you want highlights of a certain color in a dark area, underpaint that area first with a lighter color, allow it to dry, then apply the darker values. When the area is completely dry, the dark paint can be lifted with gentle scrubbing, blotted and repeated enough times to expose the lighter color. Because this method is gentle and doesn't bruise the paper, it's excellent for lightening areas that are to be repainted or detailed with opaques.

In *Scotch Pine* (below left), the lifting of color was used to produce light areas that were then repainted with opaque watercolor. Chinese white was used with yellow-green to produce the fine detail of pine foliage. Where the thickest part of the branches go into the dark background, lifting was also used. The branches were then painted with Chinese white, burnt umber and a touch of Thalo blue.

The texture developed in *Spruce* (below right) is solely the result of removing or lifting the color. No additional painting is required. For this method whatever colors are desired for the foliage should be painted first because when the top layer is lifted, it will expose whatever is under it. A little planning is required. For *Spruce* I used cadmium yellow and a touch of vermilion for the background. While it was still wet, Hooker's green, burnt sienna and Payne's gray combined to make the foliage. When all of this completely dried, I lifted the color with a stiff bristle brush that formed the foliage.

Approaching Rhome (next page, below) was the result of

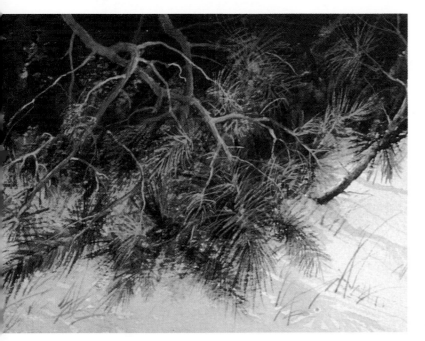

Scotch Pine
David Band
Watercolor on cold-press paper
4½″ × 5½″

Opaque watercolor of Chinese white and yellow-green was used to paint the bright foliage after the dark color had been lifted.

Spruce
Watercolor on cold-press paper
4½″ × 5½″

After the background and foliage colors were painted in and allowed to dry, the texture was produced by lifting the color with clean water and a stiff bristle brush.

combining techniques and taking a chance. It was started with a wet-in-wet sky and the traditional transparent approach for the landscape, but as the painting progressed everything seemed to run together—no interest. I went for the foreground with heavy opaque applications of Thalo blue, Hooker's green and Payne's gray to bring out the textures in the foliage and midground.

With the final highlights of Chinese white and yellow-green added to the foliage, what started out all wrong finally worked, and it's the foreground foliage that made it happen.

Detail from *Approaching Rhome*
David Band
Watercolor on cold-press paper
20″ × 28″

Thick textures of opaque watercolor produce depth and vitality in the foreground. Chinese white and yellow-green provide the highlights that strengthen the form and texture of the foliage.

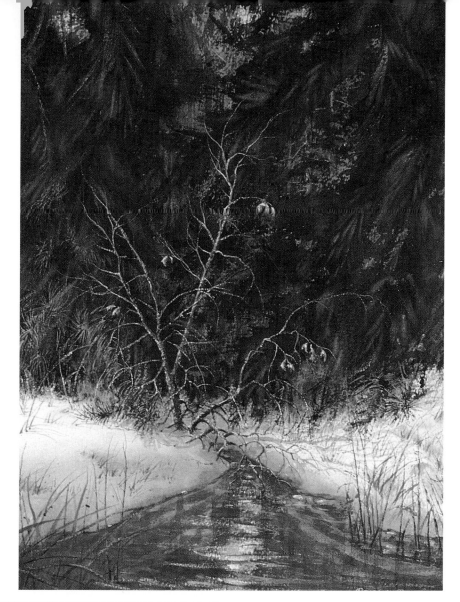

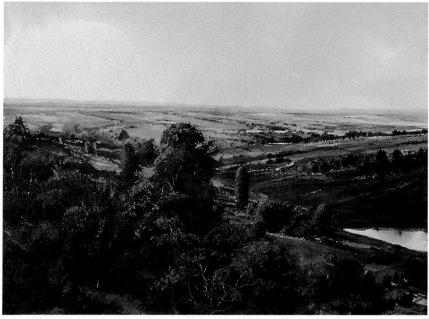

Spring Thaw
David Band
Watercolor on cold-press paper
12″ × 9″

The combination of color lifting and opaque watercolor for developing texture gives variety and depth to the background foliage.

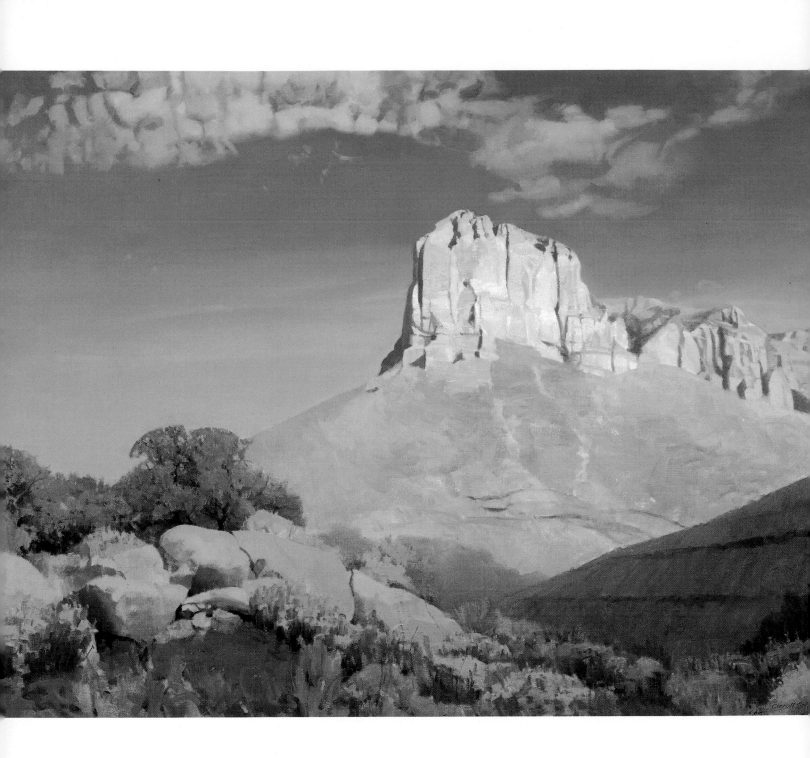

Chapter Five

Rocks

Rocks are without question one of the most interesting and diverse subjects for the painter whether they are ones with unusual color or shape as a still life subject or massive, majestic formations as the subject of a landscape. The variety of sizes, shapes, colors and textures can boggle the mind.

It's fascinating to note the differences between rocks found along the different coastlines, those found inland around rivers, lakes and streams, and the ones found in the mountains and deserts of the Southwest. But no matter where they are found, there is one thing they all have in common—it took thousands upon thousands of years to create them.

Along the Atlantic coastline, particularly in Maine, there are enormous horizontal formations of stratified rock that resemble petrified trees, one upon the other. On the Pacific coast around Northern California, the ocean has sculpted monumental vertical rock formations. The colors and textures have all been affected by the abrasive action of the pounding surf, changing tides, and staining from vegetation found in and around the ocean. Another region that is an endless source for the artist is the mountains, deserts and canyons of the Southwest, with their magnificent eroded splendor. Like the coastal rocks, these rocks have taken thousands of years of exposure to the elements to create the multicolored wind-carved formations of unusual shape and texture.

Simplifying Shapes of Large Masses

It is really easy to get caught up in the detail and character of rocks, but when you're painting them, it's best to keep it simple unless close-up texture and detail are the main subjects of your painting. Keeping it simple means to first look for the overall shape of the mass, paint it, and then put in the large light and dark areas. The cracks, holes, colors and shadows can go in later and will give the rock character. It is best to work from nature, so get out and get a firsthand look at your subject. Walk on them, touch them, and observe them in changing light.

El Capitan by Carroll Collier (page 56) is an excellent example of using shape and mass, rather than surface detail, to convey the character of the rocks. Texture is developed with strong, well-placed strokes and shadows which give a sense of harmonious simplicity to the work.

John C. Pellew's oil, *Summer Headlands*, and Kent Day Coes's *Low Tide* are two more choice examples of identifying the shapes and mass of rocks and bringing out the texture and character with light, shadows, and a minimal use of well-thought-out, expressive strokes.

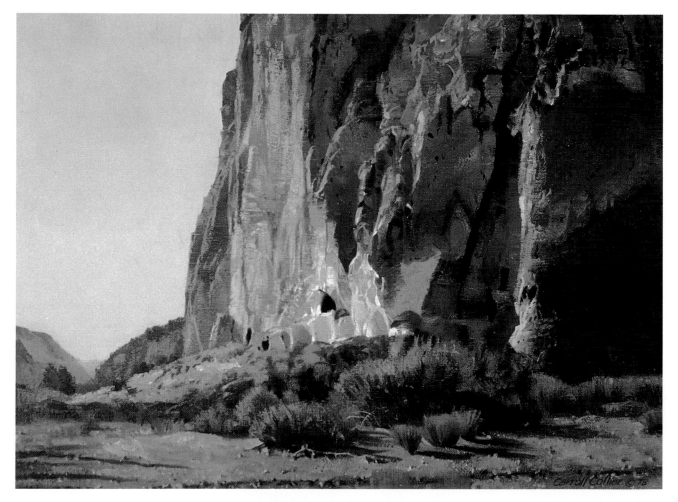

The Cliffs of Bandera
Carroll Collier
Oil on canvas
18" × 24"
Photo courtesy Baker Gallery,
Lubbock, Texas

These cliffs in New Mexico were interesting for their texture and color. Moving to a place of good advantage, I photographed this stone formation to get shapes that formed good design. I have contrasted the rock with western shrubs. I modified the local color of the stone with the usual warm sunlight and painted the cliff with less yellow modification. I then brought in some red and blue as the stone, now lighter in value, is seen in the distance. This painting was executed with a palette knife because I wanted the textural effect that the scraping of the painting knife over the underpainting (textural) can give.

Summer Headlands
John C. Pellew
Oil on panel
20″ × 28″

Pellew used a limited palette and rhythmic strokes to capture the mass and texture of the rocks found along the coastal headlands of New England.

Low Tide
Kent Day Coes
Watercolor on cold-press paper
10″ × 14″

Coes used light, shadow, and the texture of the paper to define the character of large areas of rock.

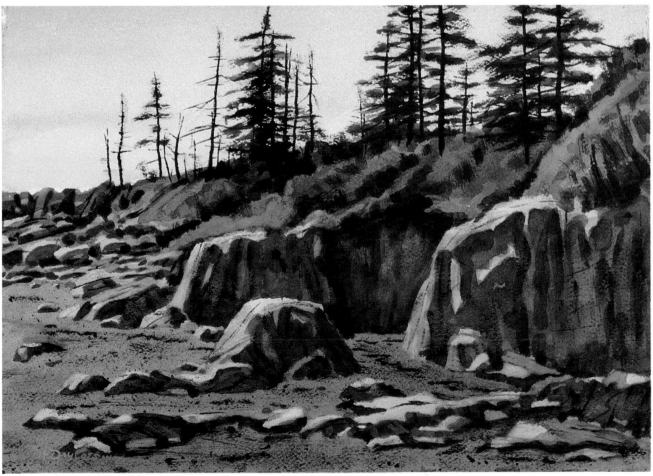

Demonstration

Simplifying With Wet and Dry Watercolor

Simplicity seems to be the key to the work of Edwin Fulwider. He can create form and texture with very few well-placed strokes, which is illustrated in his watercolor *On Idaho's Snake River*.

Fulwider's approach consists of three distinct phases: composition and drawing, the wet stage and the dry stage. He considers each to be of equal importance and indispensable in the development and completion of his work. Fulwider feels

that the contrasting qualities of wet and dry watercolor combine to make the expressive statement that is so characteristic of the liquid quality of watercolor. It is the combination of these qualities and style that produces unusual and exciting textures.

After carefully selecting a subject, Fulwider analyzes it and produces a small thumbnail sketch. The drawing is faintly suggested with pencil and then the paper is

dampened with a sponge. The first color is then applied while the paper is still wet.

The wet phase is completed in just a few minutes. When that rush is over, Fulwider relaxes and studies what's been done. Now the fun begins. Using a drier brush and a darker color, deeper tones and texture can be added. Although this process requires practice, fast work and concentration, the results can be very rewarding.

On Idaho's Snake River
Edwin Fulwider
Watercolor on rough watercolor board
10" × 14"

Step 1
The subject is analyzed and a faintly drawn thumbnail sketch is produced with light pencil. The paper is dampened with a sponge and the sky and foreground areas are put in with a light application of Thalo blue.

Step 2
Yellow ochre is applied for the landforms. A slightly darker color is dropped into the yellow to begin modeling the landforms while the paper is still wet.

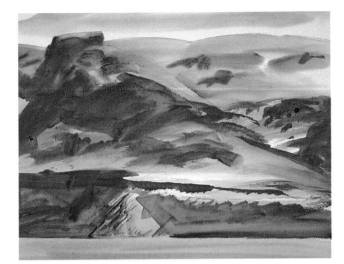

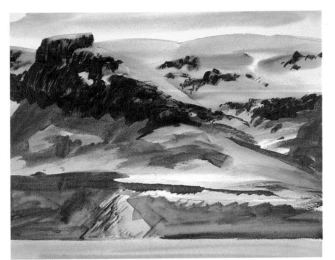

Step 3

At this point the paper is beginning to dry but there is still enough moisture to allow the addition of burnt umber to fuse with the other colors and resemble the subject forms.

Step 4

Now that the paper has dried another darker color is used to represent the deeper tones and texture of the rocky volcanic forms.

Step 5

Additional texture and continued detail painting are accomplished with a semidry brush over the areas that were painted in the wet stage.

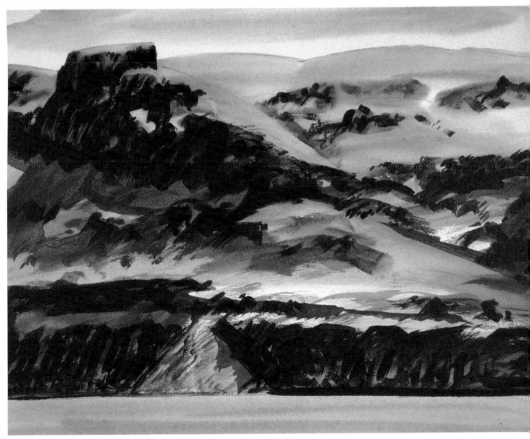

Fine Details and Texture

Now that we've taken a good look at the shape and mass of large rocks and rock formations, let's take a closer look at the textures and details. Getting close to the subject brings into play the colors, fine lines, chips, cracks, and various minerals and stains that combine to create the unique or unusual textures of rock.

Splattering. Some rocks appear to have a speckled texture, just as some look layered or marbled. How do you capture the differences in a painting? One of the most useful painting techniques to describe these textures is *splattering*. Too simple? Well, if it works, why not?

First, cover your paper (or canvas if you are using oil or acrylic)

with a fine splattering of several colors close in value. When it has dried, look for shapes that look like rocks and, using shadowing, try to define the rocks.

With watercolor I like to take this a few steps further with additional color and texture. In each step the splattering is always the foundation for the texture.

The examples on these two pages illustrate the versatility of splattering as a base texture or as a final texture. In the first phase (below), I covered the entire paper with fine-texture splatterings of burnt sienna, yellow ochre and thinned Payne's gray. I prefer a toothbrush for this, but anything that gets the job done is fine.

Leaving the top third of the paper as is, the middle and bottom

sections were each given a thin wash of different colors to change the overall feeling of the splatter. The idea is to produce different textures with different painting techniques. I used the bottom section first to paint sharp focus rocks.

The middle section was used to create the texture of rocks under water. To do this, the section was dampened and Thalo blue was dropped in around the edges of the rocks giving everything the blurry, soft appearance of looking through water.

On the top, the base texture of splatter was used as is. By adding shadows I developed the rock forms. This is the least involved of all three techniques but is equally effective.

Splatter texture for rocks
Watercolor on rough paper
13″ × 8″

The entire paper is splattered with a toothbrush using burnt sienna, yellow ochre and Payne's gray. A cadmium yellow wash is applied to the center and bottom sections, and an additional wash of Thalo blue is spread over the bottom third to intensify the base texture. Then each section is finished differently to show how splatter can be used as a base texture for a variety of finished looks.

Shadows made from a mixture of burnt sienna and Thalo blue are used to develop and form rocks from the basic splatter texture.

The look of underwater rocks is produced by wetting the paper around the edges of the rocks and then dropping Thalo blue into the wet surface around the rocks, allowing it to blend softly.

After washes of yellow and blue are used to strengthen the base texture, the detail and additional texture are added using Payne's gray and Thalo blue for a sharply focused look. A final wash of vermilion is added for color.

Demonstration
Rocks and Abstract Form

It has been said by many artists that good representational art is built on a sound abstract foundation. Rocks, alone or in groups, can form some of the most intricate and fascinating abstract patterns. There is an endless array of shapes, sizes and groupings which, when combined with the play of light and shadow, create every kind of pattern and design imaginable.

A rocky beach at low tide or the rocky shoreline of a lake or stream can provide some of the most delightful formations and patterns of sand, pebbles and rocks. *River Bed* and *Rocky Beach* show two similar subjects with different textures. Rivers, lakes and streams produce smooth, rounded rocks because of the water spilling over them continuously. In *River Bed* the rocks are shadowed to bring out the shapes and emphasize the smooth rounded texture. In *Rocky Beach* the lines, cracks, pitting and staining demonstrate the texture and help develop the shapes and forms.

Rocky Beach
David Band
Watercolor on cold-press paper
9" × 13"

Step 1
The large rocks are drawn in lightly with pencil and the basic forms are painted in with thinned burnt sienna and Thalo blue.

Step 2
Textures and contours of the rocks are painted with a small round sable using a mixture of burnt sienna and Payne's gray.

Step 3
The sand base is painted with burnt sienna, and additional rocks are added for interest using the thinned burnt sienna and Payne's gray mixture.

Step 4

At this stage the detail and texture are refined with multiple washes of a mixture of burnt sienna, Thalo blue and Payne's gray, allowing each wash to dry before adding the next. The transparent overlapping of the wash creates the stratified texture and strengthens the rock forms.

Step 5

Finally, the fine detail and finished textures are added with cracks, chips and a marbling effect in some of the flat rocks. The sharp definition is done with Payne's gray and burnt sienna. A wash of Thalo blue is used to strengthen the shadows and complete the painting.

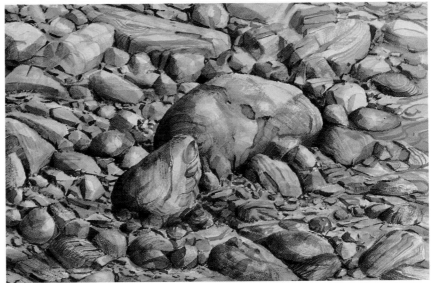

River Bed
David Band
Watercolor on cold-press paper
6″ × 9″

Light, dark and shadows define the rock shapes, leaving the smooth, rounded texture created by time and exposure to moving water.

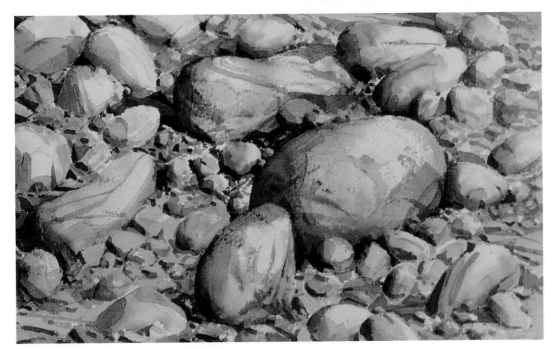

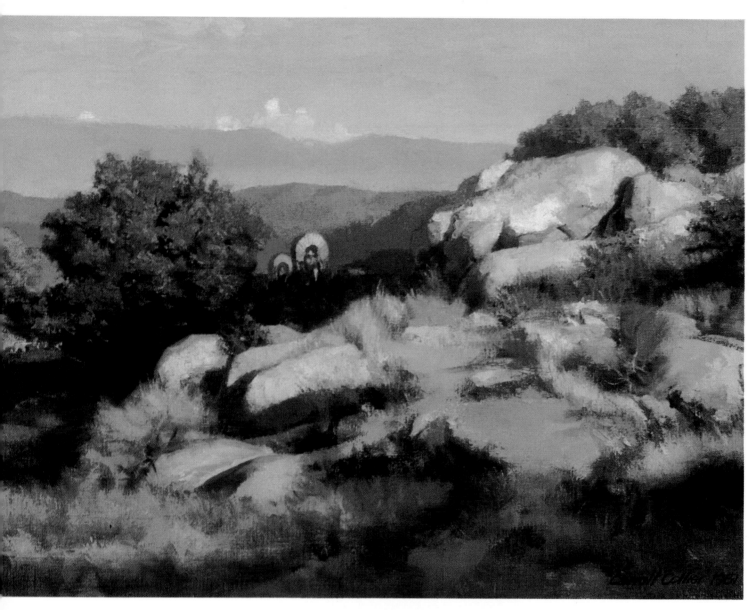

Wagons West
Carroll Collier
Oil on canvas
18" × 24"

The related shapes of rocks create a pleasant pattern. They depict strength in contrast to the frail travelers crossing this vast land in their tiny wagons in the background. The large rocks, smoothed with time, contrast with the sharp grasses and leafy texture of the tree on the left. Collier used the basic color of the rock, modified by the warm effect of the late sun. The cool shady sides of the rocks are warmed by reflected light in some areas and cooled by the influence of the sky shining on the top of the rocks. This makes it look like a real place.

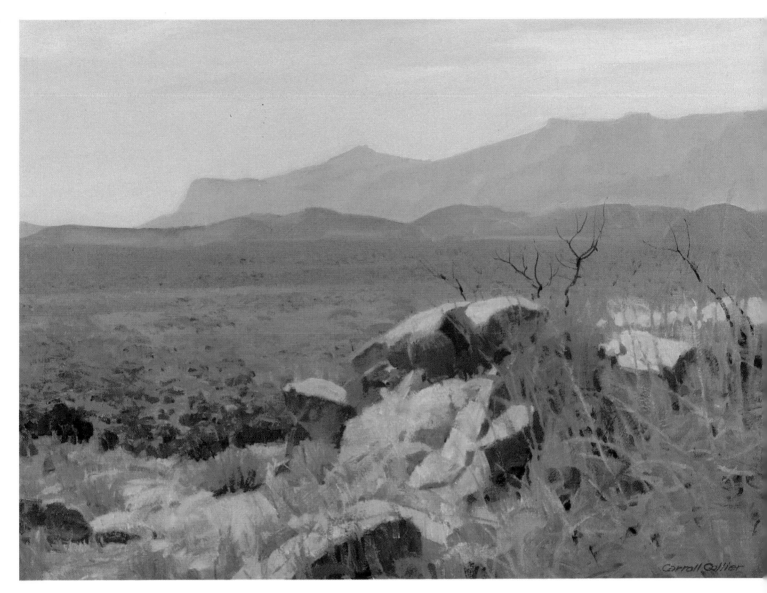

Afternoon Near Guadalupe
Carroll Collier
Oil on canvas
18″ × 24″

Rock forms create a tremendous variety of textures and patterns by themselves. But when combined with the textures and patterns of grasses, shrubs, and even landscape elements such as distant mountains, the possibilities are endless. Here Collier contrasts the mostly heavy, horizontal shapes of the rocks with the lighter, reaching verticals of the grasses.

Demonstration

Texture by Design

By repeating and overlaying similar strokes, texture can be developed with patterns and design. Rocks, and particularly large rock formations like those found in the rock walls of canyons or along the bays and inlets of coastal regions, are perfect subjects for this type of texture. Because of the stylized nature of the technique, the subject ends up somewhere between realism and abstraction in the final stage, an interesting, sometimes dramatic, approach. In *Coastal Nocturn* I used flat angular strokes with transparent watercolor to produce the design and patterns of texture.

Biddeford Pool (next page, below) is a traditional approach for a similar subject, but, if you study the shapes, shadows and angles the patterns and design become evident. Understanding how these elements are related can strengthen your work and enrich your textures.

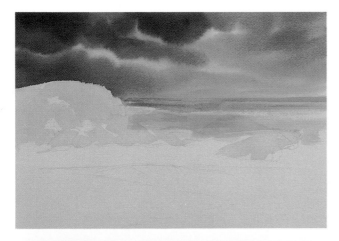

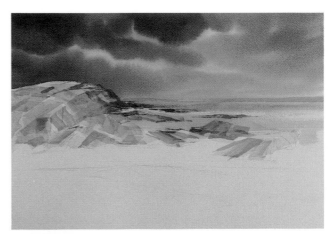

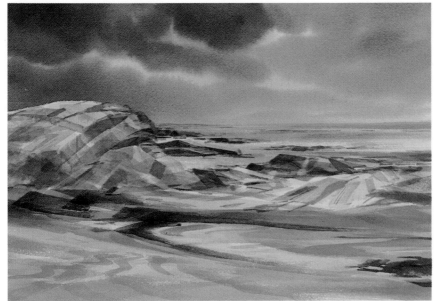

Coastal Nocturn
David Band
Watercolor on rough paper
9" × 13"

Step 1
The sky is painted wet-in-wet with a base of vermilion followed quickly with a mixture of Payne's gray and Thalo blue for the clouds. When the sky is dry the rocks are blocked in with a light application of burnt sienna and yellow ochre.

Step 2
The design is established with a flat ½-inch brush using wide strokes following the contour of the rocks.

Step 3
The beach and shallow pool are brought out with flat sweeping strokes to ensure harmony in the composition and to provide texture in the sand.

Step 4

Payne's gray and Thalo blue are used individually and as a mixture to apply the finished textures and shadows with stronger overlapping flat strokes and toning washes.

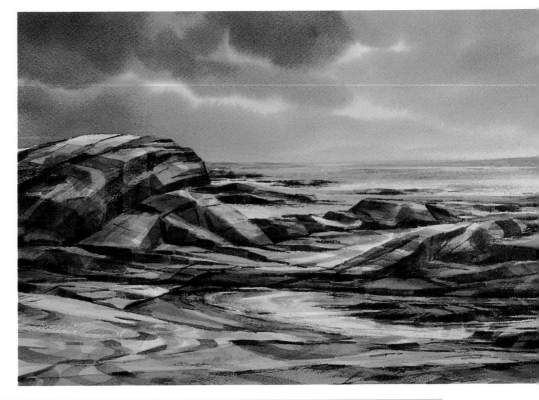

Biddeford Pool

David Band
Watercolor on cold-press paper
6" × 9"

This is a traditional approach to an almost identical subject. Looking carefully you can see the same design elements influencing the texture of the rocks.

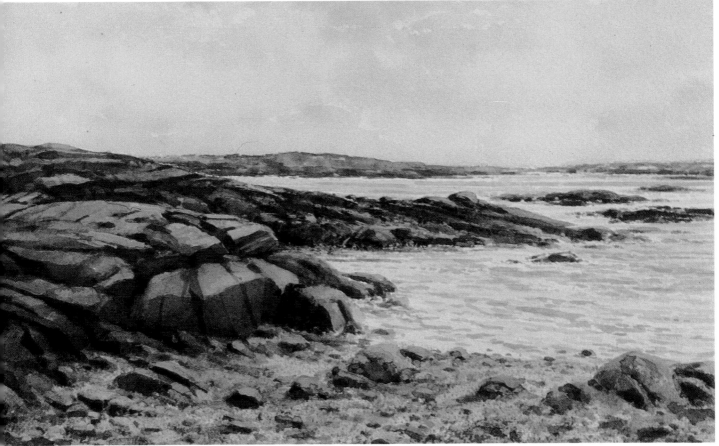

Chapter Six

Grass

Lora's Butterfly
Carroll Collier
Oil on canvas
30″ × 40″
Photo courtesy Baker
Gallery, Lubbock, Texas

Collier's granddaughter, Lora, struck an adorable pose one day while he was taking pictures. This led to finding a suitable landscape in which to place her—a grassy field, wildflowers, butterfly, billowy clouds, and a few trees to add interest. He painted in the dark masses depicting the grassy area, and the lighter areas with thick paint, adding variations of color, finally adding wildflowers. He used broad strokes painted with a free spontaneous motion allowing the texture to imply a lot of grass, then adding a few strokes with his detail round sable brush to make the area convincing yet not overworked.

Grass is another one of those things we take for granted. I can't imagine being unable to describe it if someone were asked, "What is grass?"

Often we speak of a blade of grass. The word *blade* immediately brings an image to mind of something long, narrow and perhaps flat. Individual blades of grass are texturally unremarkable, but collectively they have strength, character, body, design and varied textures. Grass has an extraordinary range of growth and adaptation and is found everywhere in the world, having 4,500 different species.

What we find in our own yards, fields and wooded areas is really all we need to focus on for our purposes, so let's look at what we know. To really understand its texture, getting close to it is the only way. Words like *plush*, *soft* or *carpetlike* could be used for well-kept, manicured lawns, just as *rough*, *prickly* and *dry* could describe the untended grass on the other side of the fence. What about the grass that has been *crushed* and *matted down* from being under a heavy object? What texture does it have? When grass is *thick* the blades tend to merge creating a *woven* appearance. If it has rained, or been particularly dry, the texture of the grass will be affected. Because of the numerous factors that can affect grass texture, we have the freedom to see it and interpret it as we choose. It can be a broad, flat stroke representing an entire field, or a fine, fragile blade peeking through a mound of snow.

Variations in Grass Textures

When the wind blows through grass it poses an interesting problem for the artist: how to capture the texture of *movement*. Seeing grass up close or at a distance changes texture, too. How to paint these differences while remaining consistent with depth, perspective and texture are but a few of the

questions to be answered. Let's begin by contrasting *Fall Field* and, *Woodland Clearing* two small watercolors with a similar subject, handled with two distinctly different textures.

Fall Field is painted dry, taking advantage of hard edges to produce the texture in all areas of the painting.

Sharp focus texturing in the foreground grass is carried back to

the horizon with distinct hard-edge patterns emerging from wider strokes, without losing the depth of the field or the feeling of thick, dry autumn grass.

In *Woodland Clearing*, the use of wet-in-wet for the background and foreground provides a soft base texture, combined with dry-brushed details to give the feeling of a wet day in the process of clearing. The thick, soft texture of the grass is produced with wide, semi-wet strokes, followed by a few dry accent strokes. The objective is to capture the feeling of soft, thick grass with only as much detail as necessary. The texture and depth remain consistent by gradually softening and lightening the strokes and color as the grass merges with the misty tree line.

Fall Field
David Band
Watercolor on cold-press paper
4" × 5½"

The thick woven texture of the dry autumn grass was built up by an overlapping series of light to dark strokes with no. 0 and no. 000 detail brushes. The same strokes were used for the midground in a looser, less regular pattern.

Woodland Clearing
David Band
Watercolor on cold-press paper
4" × 5½"

The basic grass forms were done wet-in-wet to produce a soft, thick appearance. The finishing texture was painted in with no. 0 and no. 4 round sable brushes to suggest the length and volume of the grass with soft lines, spots and blotches of color.

Painting Grass Wet-in-Wet

The wet-in-wet process is an excellent way to start any number of grass textures because it can be left in its initial stages for soft vague forms or built up with stronger layers of color and texture. Any of the stages can be left as a finished product. The controlled wet-in-wet method can be used to deepen colors and strengthen texture, as in *Forgotten Dreams*. Because I was looking for a certain depth of color and volume in the grass, I chose this method rather than traditional wet-in-wet where the colors have a tendency to wash out or lighten. *Forgotten Dreams* required seven layers of gradual building with yellow ochre, burnt sienna, Hooker's green and burnt umber to create the color and texture I was seeking.

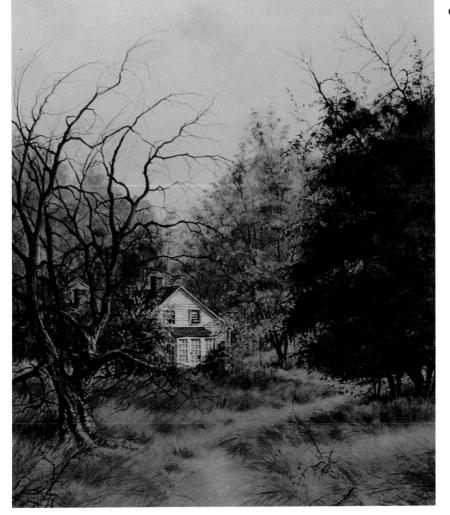

Forgotten Dreams
David Band
Watercolor on cold-press paper
20″ × 28″
Collection of Mr. and Mrs. Donald McMullen

To capture the full, dry texture of the autumn grass, seven layers of burnt sienna, yellow ochre, Hooker's green, and small amounts of burnt umber were used with the controlled wet-in-wet process.

Detail
Here the rhythm and texture of the grass are enhanced by the soft shadows in the thick undergrowth.

Detail
The final details for the foreground are painted in dry with burnt umber and Payne's gray to bring out a sense of weight, volume and the dry texture of the autumn grass.

Demonstration
Layering Color for Depth

The beauty of the controlled wet-in-wet technique is that it gives you time to think and plan the next step while you are painting, whereas traditional wet-in-wet requires pre-planning for each stage and rapid execution.

For this demonstration I selected 140-lb. cold-press paper because it gives the soft blended col-ors of the grass just enough back-ground texture to add interest to the flat areas. First I dampened the paper with a sponge and clean wa-ter, working the water into the pa-per to avoid pooling. A thin mixture of color was applied with a 1-inch wash brush in a loose, unstruc-tured manner and allowed to blend. As it started to dry, the grass forms began to take shape. The pa-per was dried, dampened again with a sponge and a few areas were painted with burnt sienna to begin shaping the grass.

I repeated this process several times with slightly stronger colors and smaller brushes to add detail and texture to the grass.

Controlled wet-in-wet
Watercolor on cold-press paper
6″ × 9″

Step 1
The paper is dampened with a sponge and clean water. A 1-inch wash brush is used to apply the initial background colors of yellow ochre and burnt sienna.

Step 2
After the first step has dried, the paper is dampened again and the gradual buildup of color and texture begins with slightly stronger yellow ochre and burnt sienna.

Step 3
Here the process is repeated with a little more emphasis on form and texture using burnt umber and a touch of Payne's gray to deepen the burnt sienna.

Step 4

After the paper has dried and been dampened again, a wash of thinned yellow ochre and burnt sienna is applied to the entire surface. While the paper is still wet, a mixture of burnt umber and burnt sienna is applied with smaller brushes to give more definition and volume to the grass forms.

Step 5

Using a mixture of burnt umber and burnt sienna, the foreground details and final textures are completed with a no. 2 round sable and a no. 0 detail brush to accentuate the depth and soft texture of the grass.

Special Effects

Special effects refers to the use of different tools or objects to produce a certain look. For example, you could use the end of a brush handle to scrape with or a razor blade to etch highlights. Sometimes hard erasers are used to rough up the surface. When the area is repainted, the pigments are absorbed more intensely.

Squeezing Color. A hot-press paper or board is an excellent surface for scraping or squeezing color from an area using a hard object and pressure. I prefer the term *squeezing* because the surface and pigment need to be wet for it to work.

Preplanning is important because hot-press or slick surfaces seem to dry much quicker than other surfaces. It is important to know exactly what you want to do and move quickly. When I use this technique for grass, the end of a brush handle works best for blades of grass. The texture is affected by the amount of water in the paint and moisture in the paper.

Whenever a hard or sharp object is used to squeeze or force paint from a wet surface, it is very easy to scuff or disturb the paper's surface. When the pigment tries to flow back into the area a jagged or irregular edge occurs causing a rough texture.

Smoother textures can be achieved by reducing the amount of water in the paint and surface.

For a clean image with smooth texture, paint a very loose background with a thin application of paint. Allow a few seconds for the paint to set and the surface to remain damp, then use the brush handle end to squeeze or force the pigment out of the paper to form the blades of grass. To achieve a more irregular texture use more water in the paint and the surface. This will form a softer background.

The background colors of burnt sienna and Hooker's green are applied to a clean, dry, hot-press board with broad, loose strokes and just enough water to allow the paint to flow easily. The end of the brush handle has just the right shape to squeeze the paint out of the damp surface in the shape and texture of grass blades. To ensure clean, hard-edged strokes and texture, it is important to let the surface dry for a few seconds before the squeezing or scraping begins.

A wet-in-wet background using yellow, Hooker's green, and a little burnt sienna was used to create a soft background for a more irregular or jagged texture in the blades of grass. Because a hot-press surface does not absorb water as well as the other papers, moisture has a tendency to soften the surface which makes it easy to bruise or scuff the paper. The scuffing is what produces the texture when the paint tries to flow back into the disturbed area.

Drybrush

Whether you are painting the texture of a distant landscape or the finely detailed texture of grass only a few feet away, drybrush with its special effects and painterly characteristics can produce exceptionally rich textures. The brush and how it is used are just as significant as the surface and the paints and how they are applied.

A flat-end brush works wonders for adding patterns in grass or bringing out the contours in a landscape by shaping and modeling the ground-level changes. Building texture by crosshatching or scumbling can be done easily by spreading the bristles of almost any type of brush to control the width and consistency of the stroke and texture.

In *Stonington*, all of the texture in the painting was created with a ½-inch flat-end aquarelle brush. The background is a flat application of Thalo blue and Payne's gray to show the fog beginning to roll in from the sea. The trees are a mixture of Payne's gray and Hooker's green developed with flat, crosshatching strokes and dry scumbling for the texture on the branch ends.

The real fun began after a base of yellow ochre and yellow-green in the grass area had dried. Here the flat-end brush shows its versatility. Using stronger mixtures of yellow ochre and yellow-green I built up the patterns of the grass with transparent layers. Defining the forms and the different grass levels was done by spreading the bristles and crosshatching with thinned Hooker's green into curved overlapping patterns. The final texture was added with Payne's gray and Hooker's green. I lightly dragged the brush in an upward motion with the bristles tightly together. The land form, grass texture and shadows were completed with the same strokes.

Stonington
David Band
Watercolor on rough paper
9″ × 13″

Stonington was developed completely with a series of dry brush textures. Texture was used for subject composition and detail. Careful layering light to dark with a flat-end aquarelle brush preserved the soft textures and mood of the painting.

Detail
Here the faint outline of the many layers of crossover strokes can be seen with the shaping effect and texture produced by lightly dusting the rough surface with a dry brush.

Demonstration
Layering Dry Flat Strokes

The flat-end brush is very versatile and is equally effective for both closeup and distance work. It can produce muted or soft textures as effectively as it handles closeup, more detailed textures.

Rocks and Grass was painted the same way as *Stonington*. All of the texture was produced with layers of dry flat strokes. The foundation colors of yellow ochre and yellow-green were used to loosely block in the land forms and Payne's gray with Hooker's green did the same for the trees. Flat angular strokes were used to structure the rocks and develop a rhythm. Using a ½-inch aquarelle brush with the bristles sometimes tight and other times spread apart, I created the different grass textures. The flat end of the brush was used to shape and model the rocks and land mass before the final colors and textures were added.

Watercolor on cold-press paper
By spreading the bristles of a flat-end brush, grass can be painted quickly using crosshatching or crossover patterns to add texture and volume.

Rocks and Grass
David Band
Watercolor on cold-press paper
6″ × 9″

Step 1
The background trees, rocks and foreground grass are painted in very loosely with quick flat strokes.

Step 2
Rock forms, trees and grass are gradually developed with dry brush texture using Payne's gray and Hooker's green for the foliage, yellow-green and yellow ochre for the grass, and a touch of thinned Payne's gray in the rocks.

Step 3

The subject is intensified by strengthening the color and fanning the bristles for additional texture.

Step 4

In this stage all of the background texture has been completed with layers of dry flat strokes. The rocks and grassy areas have been defined by this method so it is time for the final touches. A light layer of Hooker's green and yellow ochre is applied to the grass with very little water for color and volume. If too much water is used the colors will blend and eliminate a lot of the texture.

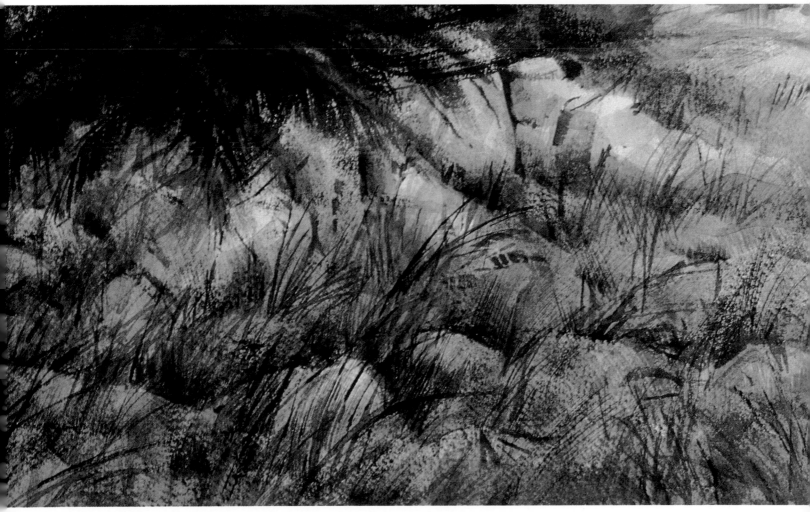

Demonstration
Dry Brush on Rough Paper

Broad flat strokes in a very dry and loose manner were used to shape the land and grass areas in *Rangely Region* (below). The idea was to structure the land form but retain the soft texture of the grass. The initial strokes consisted of yellow ochre, yellow-green and burnt sienna applied with the bristles tightly together and with just enough pressure for pigment to be picked up by the surface of the 140-lb. rough paper.

The grass texture was built up slowly with several "dustings" of the foundation colors which adds body and character to the grass while retaining the grainy texture supplied by the paper. I kept everything as dry as possible to keep the texture secure. Too much water causes the pigments to blend so I make it a habit to test my stroke on a scrap of paper or squeeze the bristles before picking up paint for the next layer.

When I was satisfied with the texture and mood of the painting, I added final details using a mixture of Hooker's green and burnt sienna—but very sparingly.

Rangely Region
David Band
Watercolor on rough paper
6" × 9"

Step 1
Broad flat strokes of yellow ochre, yellow-green and burnt sienna are applied lightly, very dry and mostly horizontally to begin structuring the land mass.

Step 2
The same process is continued in this stage with gradual darkening of the colors to indicate contours and shaping of the landforms.

Watercolor on rough paper
This texture is produced by lightly dragging a dry brush and pigment over the rough paper's surface. Any number of effective textures can be developed by layering and varying the length of the stroke.

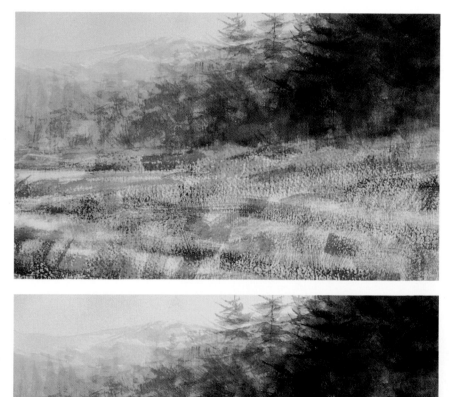

Step 3

Wide transparent layers of thinned burnt sienna and yellow ochre are introduced with horizontal strokes over the grassy areas for color and to soften the overall texture.

Step 4

In the final stage continued softening of the base textures is done with very dry mixtures of burnt sienna and Hooker's green being dragged very lightly over the grass. The changes are very subtle, but with several "dustings" the distant soft look is completed.

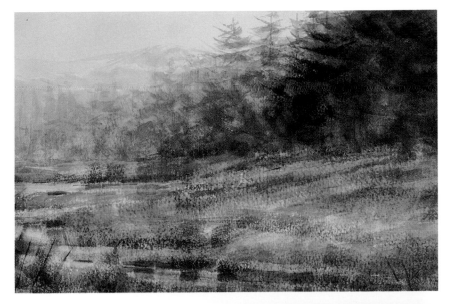

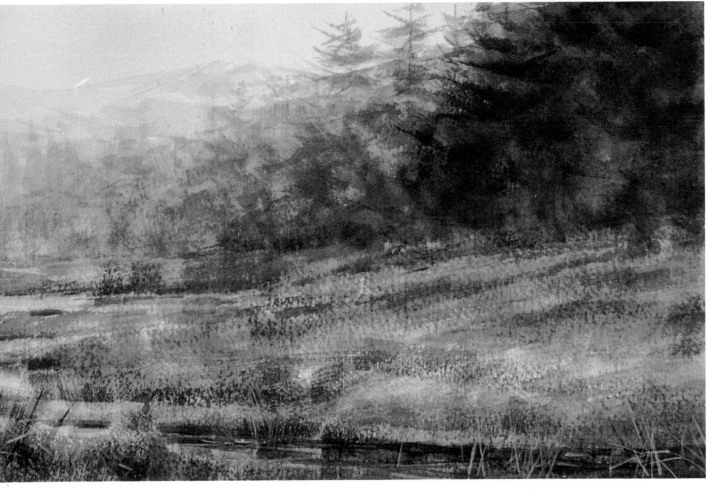

Restoring Texture With Opaques

No matter what style we use or what combination of materials we choose, there are always those times when our paintings seem a little flat or lifeless. This generally happens when colors get muddy and the texture is lost from over-work or things just didn't come out the way we planned.

At times like this, color, texture and character can be restored with some opaque watercolor. In the paintings below, I used Chinese white and yellow-green to revive some grass that was lacking in interest and texture.

In his watercolor *Rural Rail-road*, Edgar A. Whitney used opaque watercolor to add interest and texture to a large area. He was definitely a master of saying so much with so little. The minimal use of bright opaque strokes gives vitality to the painting and adds just the right touch to the flat grass areas.

What we've covered in this chapter are only a few of the techniques available with watercolor. The other mediums have their own specialties and charm, but no matter what medium is used, it is the willingness to experiment and keeping an open mind that allows us to discover ourselves in our work.

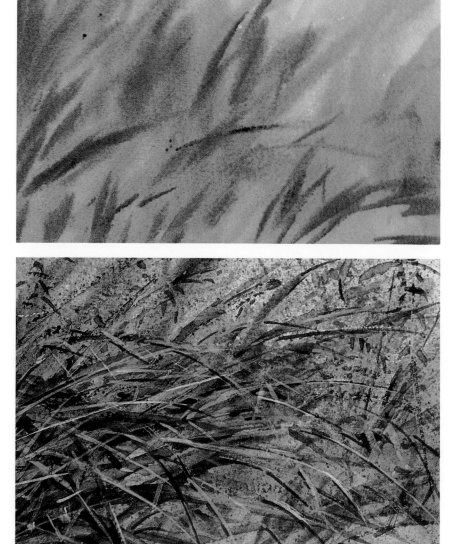

Step 1

With a standard wet-in-wet approach on cold-press paper, this patch of grass is painted with cadmium yellow as the background and Hooker's green for the grass. As the paint dries the colors will become flat and the shapes vague.

Step 2

The restoration of texture is done with a building up of colors and depth using several layers of Hooker's green, yellow-green and Chinese white. Each layer is painted dry, gradually lightening the colors until the final strokes of Chinese white and yellow-green are used for the finishing touch.

Rural Railroad
Edgar A. Whitney
Watercolor on 140-lb. rough paper
14″ × 20″

Ed Whitney's *Rural Railroad* is a fine example of how large areas of color can be enriched with splashes of opaque color. The texture of the grass both in the mid- and foreground is suggested with the spontaneous and uncontrived use of opaque lines and splashes.

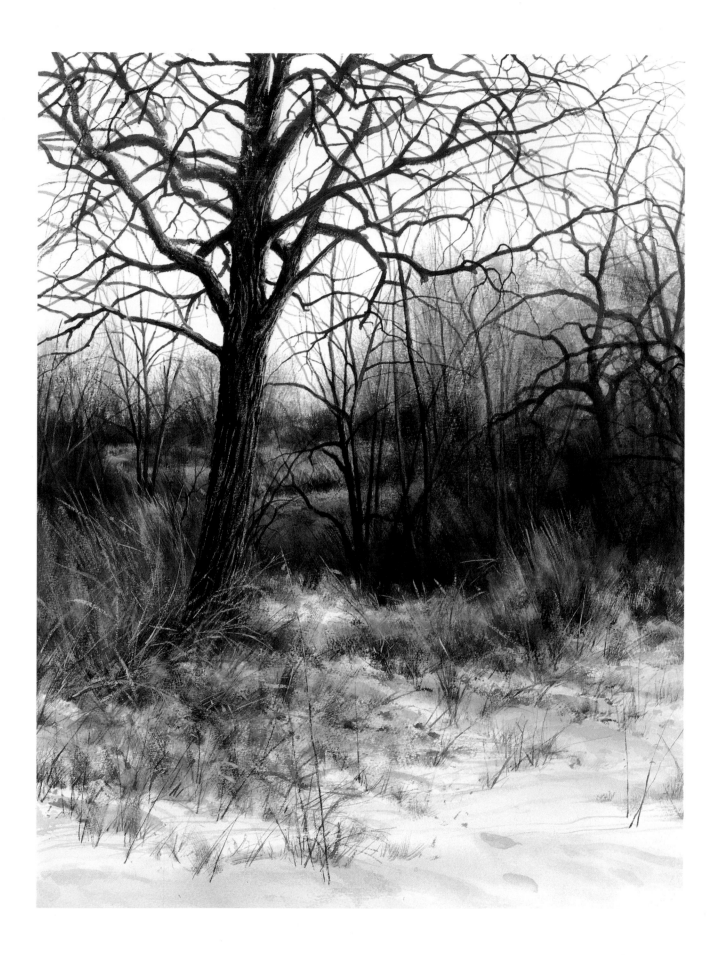

Chapter Seven
Snow

Snow is one of those things that must be seen and touched to fully appreciate its texture. Broadly classified, snow is hard or soft, old or new. Weather conditions play an important role in determining snow's texture. Strong, whipping winds cause drifting and dramatic contours.

Freezing temperatures and rain cause a brittle icy coating which becomes hard snow. New snow has a whiter-than-white brilliance that attracts and reflects light. The longer it remains on the ground, the duller and more porous it becomes from traffic and windblown dirt.

Soft snow is the natural product of a dry powderlike fall or it can take on the appearance of being soft when temperatures rise and a gradual melting softens the sharp contours.

Regardless of what kind of snow it is, the contour and characteristics of what lies beneath it will also affect the texture. As with any landscape, the appearance of snow changes depending on the vantage point from which it is viewed. From a distance it all looks soft.

Soft Snow

Snow looks soft, but looks can be deceiving. The real soft snow is that "dry" powdery stuff that looks like cotton. It has that fluffy white, blow-away appearance that requires below-freezing temperatures to remain dry. Otherwise it will melt, lose the light texture and become heavy with moisture.

The surface of a canvas for oil or of paper for pastel painting is excellent for picking up the texture of soft and blowing snow when the paint or pastel is lightly dragged over the surface. If you are using watercolor, the paper *is* the snow and the color and texture depend on what you add and what is left untouched.

Generally, the deeper the snow is, the softer it looks and, after all, painting is about capturing appearance. Remember it is the sharp edges and strong contrasts that give snow that hard look, so blend and soften your strokes, remove the edges, and you will have soft snow.

Hard Snow

Hard snow, like soft snow, might have a tactile texture different from how it appears. The real hard-to-the-touch snow is the natural product of the weather conditions during and after the snowfall. Freezing rain and winds that whip the snow into swirling shapes and drifts coat the snow with an icy, slick crust.

The other kind of hard snow is caused by any number of things such as packing from additional snowfall and moisture from warming temperatures.

It is the packing created by weather, animal and human traffic that gives snow its "hard" appearance by creating shadows, color contrasts, depressions, patterns and ridges. This texture can occur in snow of any depth, but the colder it is, the harder the snow will be.

In Kent Day Coes's watercolor, *Midwinter Stroll*, he used light to illuminate the texture of snow. Coes's handling of the dazzling light, a familiar part of cold, crisp winter mornings, makes the snow seem whiter than white. The sharp angles and clean lines of the shadows and ruts accentuate the snow's depth and texture.

In *Tracks*, I was trying to capture the time of day in the color of the snow. I had seen this place so many times in all kinds of light and seasons. But it was this very cold late afternoon in February that stopped me in my tracks. The sun was going down and the temperature had dropped significantly which put a shallow crust over the snow's surface. This thin glaze reflected the colors in the sky much like the water in a clear lake would, and gave the landscape a surreal quality.

Rusty Tractor
Carroll Collier
Oil
18″ × 24″
Photo courtesy Baker Gallery,
Lubbock, Texas

Collier likes to use thick paint when depicting snow, but he always builds up slowly. He feels that too much paint too soon limits him to a smooth texture.

Although the snow in *Rusty Tractor* is fairly deep, it is obvious that the sun has warmed the tractor and a gradual melting is happening. This melting has caused a rounding of sharp edges and a softening of strong contrasts that gives the snow a soft appearance.

Midwinter Stroll
Kent Day Coes
Watercolor on cold-press paper
10″ × 14″

Coes used a limited palette to produce this very cold painting. The strength and angle of his shadows enable us to sense the cold hard texture of the snow. You can almost hear the snow crunching.

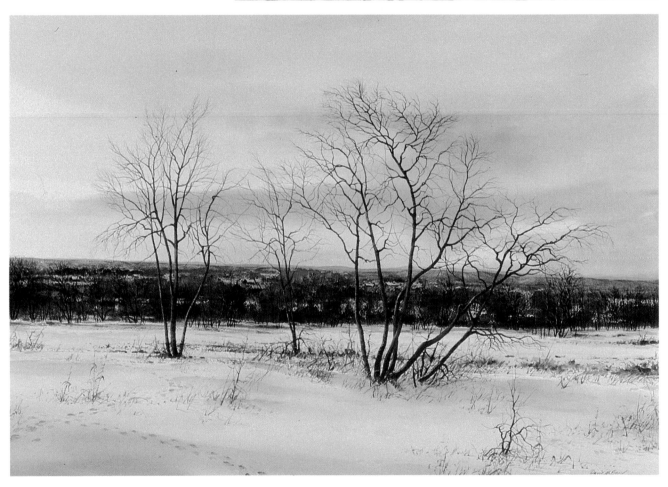

Tracks
David Band
Watercolor
20″ × 28″

To keep the snow texture smooth and crisp, I selected a cold-press paper for its medium-textured surface. The sky was first washed with a loose application of cadmium yellow, followed quickly with a mixture of alizarin crimson and vermilion.

Although the sky was done wet-in-wet, the colors were not put in until the surface dried to damp. This ensured soft textures without losing the cloud mass. The distant hills and tree line of the middle ground were painted dry with some soft scumbling for the treetops using mixtures of alizarin crimson, Payne's gray, burnt sienna, raw umber and Thalo blue. The controlled wet-in-wet technique was used for the snowfields with the same colors that were used in the sky. Controlled wet-in-wet has a way of absorbing layers of color without losing the transparent quality of watercolor. That is what I needed for that cold, late afternoon feeling. The clean, defined shapes of the tracks are the key to the snow's texture. If the snow was soft and fluffy, the tracks would be longer and less distinct. Because the snow is hard and packed, the tracks are firm and clean.

New Snow

The most outstanding characteristic of new snow is how white it is. It is the purest white imaginable, so much so that it seems to cleanse its surroundings.

It is amazing how bright it is at night during a snowfall due to reflected light from windows, autos and streetlamps being carried on the moving snow. Sunlight makes fresh snow sparkle with blinding brilliance, whether it is a light, floating dusting of snow or a heavy fall with wind-carved drifts.

New Snow was originally planned to illustrate how new snow conforms to landforms, but as it progressed, I decided to include the texture of a snowfall in progress. But before adding the falling snow, I had to darken the background trees and add large areas of color, including dry grass and underbrush to the foreground and middle ground. With the darker additions, the falling flakes could be seen on all planes, which strengthened the composition, atmosphere and depth.

New Snow
David Band
Watercolor
20″ × 15″

Everything was painted with a dry brush except for the sky and a few shadows in the foreground. The sky was painted first with a very thin mixture of vermilion and Payne's gray into a damp surface. When this dried, the background trees were put in with a thinned mixture of Payne's gray, vermilion and burnt sienna. The challenge was to develop a very dense background without losing light so the larger, darker trees would not be lost in the background. Next the grass was worked in with yellow ochre and burnt sienna with a ½-inch flat-end brush using upward strokes. After a few final details, shading and some small trees, I added the falling snow, using a soft bristle toothbrush and Chinese white. A word of caution—to get an even texture with enough air between the snowflakes, draw your index finger slowly over the bristles. Quick stroking produces a dense splatter pattern. Keep the brush moving, six to eight inches from the surface, to avoid dense spots.

Old Snow

Old snow begins to develop that "old" look relatively soon after it begins to absorb traffic. It takes on the color and texture of its environment.

In just a few short days the brilliance begins to fade and the smooth texture becomes rough and porous as the moisture finds its way to the ground. The earth or un-derlying structure begins to emerge, which affects the color and texture of the snow.

In Henry M. Gasser's watercolor *The Yellow House*, he incorporated these various textures as they were developing. As the snow has melted, the rooftops and fur-roughed rows of the garden area have become more visible. The deep drifted areas in the fore-ground still have the clean, un-touched, smooth texture while the cleared pathway into the middle ground shows the texture and color of traffic.

John C. Pellew's watercolor *Winter Clearing* shows the loss of brilliance and flattening of aging snow. Pellew's fluid and spontaneous brushwork captures the feeling of the shrinking snow with toning, color, tracks and impressions of the land forms.

The Yellow House
Henry M. Gasser
Watercolor
22″ × 30″

In this painting Gasser has given us a lot of activity in a quiet painting through the range of snow texture. It is obvious that this is not new snow because of the thin melted areas where rooftops and patches of ground have been exposed. And yet, clean, bright areas remain due to their depth and not being in traffic areas.

Winter Clearing
John C. Pellew
Watercolor
12″ × 18″

Pellew used a dry-brush technique with bold, free strokes to best utilize the rough texture of the paper. Yellow ochre and burnt sienna suggest dry grass, brush and exposed land with dry applications of thinned Thalo blue and yellow ochre for snow texture and tone.

Demonstration
Using Texture to Reveal Form

The form of objects and land mass can be defined by texture. In *Cuttings*, snow texture is used for this purpose. In this painting, I used a soft light to capture the atmosphere and convey a sense of warmth to validate a feeling of melting or softening of the snow.

As snow softens it conforms to the contours of the land and objects it is covering. The absence of snow on the foliage and upright trees supports the warming effect. Because the snow has been on the ground for some time, it has lost its brilliance in most places.

Cuttings
David Band
Watercolor
9″ × 13″

Step 1

A light wash of Naples yellow is applied to the entire background to create a warm light. The background trees and dense foliage are then painted with several layers of Hooker's green, Thalo blue and yellow ochre to soften the color. A thinned shaping wash of alizarin crimson and Thalo blue is applied to begin the snow texture.

Step 2

With the background foliage complete, a few detail trees are painted in with Payne's gray and burnt sienna against the lighter foliage on the right. Others are color-lifted on the left with a stiff bristle brush and water.

Step 3

The stumps and fallen trees indicated lightly with thinned burnt sienna in the initial steps are now strengthened and textured with burnt sienna and Payne's gray using the dry-brush technique. Dry-brush with the 140-lb. rough paper is excellent for producing the texture of snow caught in the rough bark, because the rough surface of the paper becomes the snow where the pigment has missed.

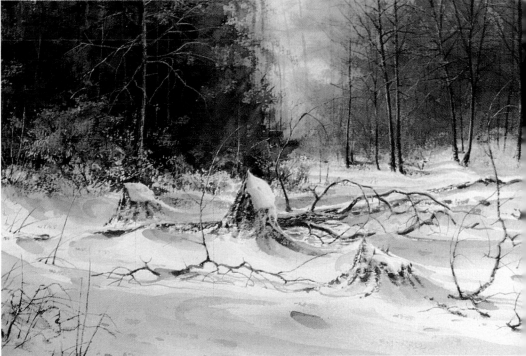

Step 4

In this step I strengthen the shapes and shadows of the snow with additional washes of alizarin crimson and Thalo blue using a 1-inch round wash brush, both wet and dry. The broad, sweeping strokes tell us something about the depth and texture of the snow.

Step 5

Deeper color, shading, and broad, sweeping, hard-edged strokes are used to define landforms and suggest the depth and texture of the snow.

Step 6

In the final stage, finishing detail, animal tracks and depressions are applied with splatter and additional strokes and washes of alizarin crimson and Thalo blue. The background trees and branches are highlighted with a mixture of Naples yellow and Chinese white.

Demonstration
Layering Textures in Pastel

Spring Thaw by Kaye Franklin is a fresh example of the textures and characteristics of snow, interpreted in pastel. Franklin's style provides energy and vitality to her work, with a balance of soft and bold strokes. She uses the special qualities of pastel in an intuitive and painterly fashion.

Here she used a sanded paper with a strong "tooth" because the snow texture required several layers of light to dark pastels.

To begin, Franklin painted the dark areas with very little pressure, adding a few highlights and local color for contrast. Next, a turpentine wash was used to bring the composition together quickly by strengthening shapes. Franklin combined the use of turpentine washes with well-directed strokes and an experienced eye for color to create this peaceful composition.

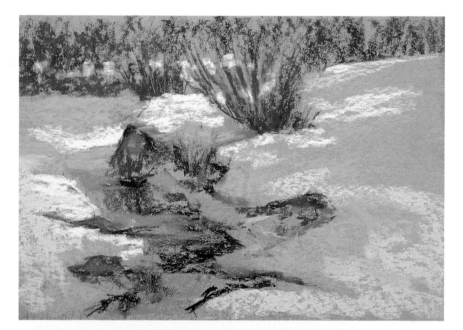

Spring Thaw
Kaye Franklin
Pastel on sanded paper
9" × 12"

Step 1
Using very light pressure, Franklin lays in the dark areas on the sanded paper. Next a cool blue and violet are used to capture the lighter value of shadows on the snow.

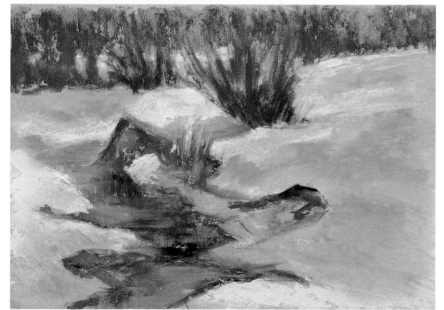

Step 2
To pull the painting together quickly and strengthen shapes, a turpentine wash is applied using a bristle brush. The dark wash in the stream pulls the reflections downward.

Step 3

When the washes are completely dry, more local color and light are added with heavier pressure. To strengthen the focal area, combinations of yellow-white and pink-white are used in the snow around the bush and toward the background, allowing some of the underpainting to show through.

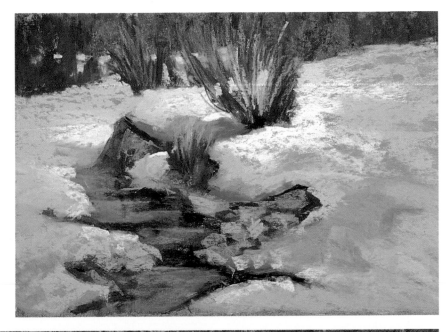

Step 4

Additional light and texture are added with heavier strokes of yellow-white for the snow and water. Franklin pays strict attention to stroke direction as she completes the work with final touches of reflected light on the bush.

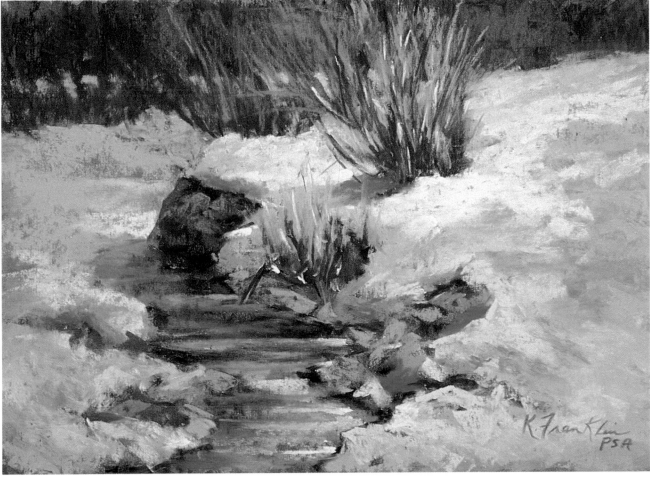

Demonstration
Using the White of the Paper

January is a small watercolor that illustrates the effectiveness of using the white of the paper as new snow. I painted with a dry brush, paying attention primarily to the use of strokes and edges for texture content, and painting around the snow with foliage and texture to establish the atmosphere. At just about every stage of development, the painting had the feel of bright white fresh snow. Light contrasting washes were used sparingly in the snow for depth and tone. For interest, some thin dry grass, a few saplings and some Thalo blue for shadows completed the painting with a crisp, clean feeling.

January
David Band
Watercolor
6" × 9"

Step 1
The background and foliage are painted in dry using burnt sienna, Payne's gray and Hooker's green with a ½-inch flat-end brush. Spreading the bristles and stroking in an upward manner supplies the texture for the foliage edges.

Step 2
Using a very thin mixture of Thalo blue and alizarin crimson, the foreground snow is toned and the low brush is defined with a few quick upward strokes of burnt sienna and Payne's gray.

Step 3

Dry, thin grass is added with thinned burnt sienna along with a few additional flat strokes of Payne's gray and burnt sienna to strengthen the brush and give shape to the landforms.

Step 4

Burnt sienna and Payne's gray are now used to paint the saplings and add faint, deep background trees for atmosphere. Final detail and shadows are painted with a thin application of Thalo blue.

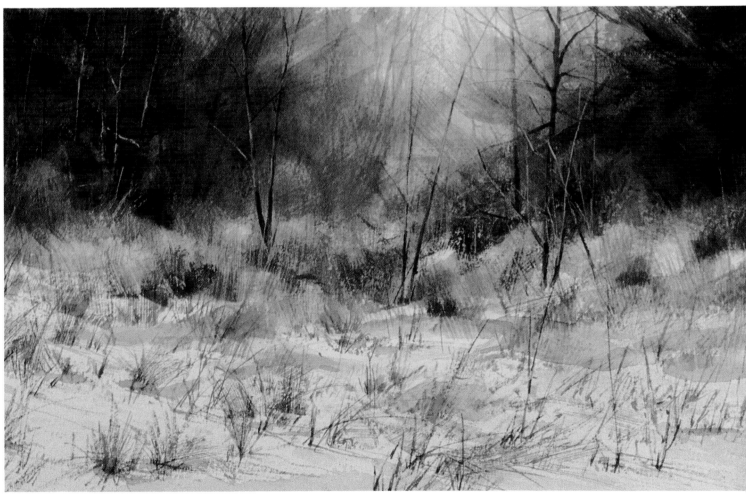

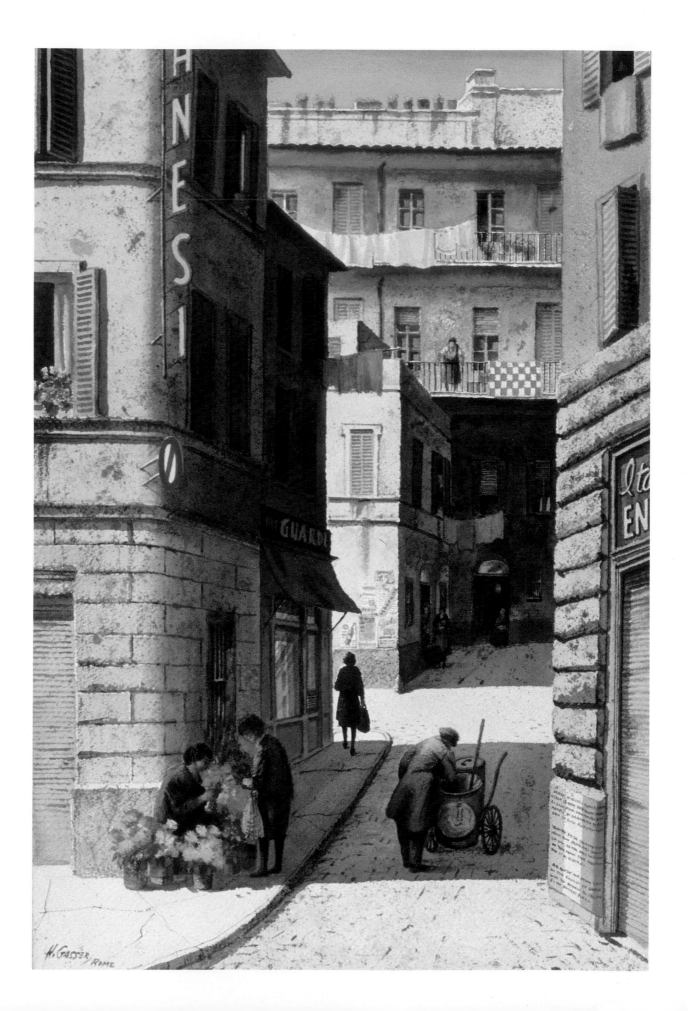

Chapter 8
Buildings

Although buildings and houses are manmade, it is time and nature that bring about the textures and character that create so much interest in old forgotten structures.

The key word is *character*. In an old house or building, character can be seen in the sagging lines and angles, unusual architecture and aging materials like broken glass, peeling paint, and cracked, pitted, discolored bricks.

In a newer structure character is most likely found in the unusual lines, shapes, angles, colors and patterns created by cast shadows. In each case, the textures build character.

As with all things regarding texture, it is best to examine buildings up close and touch them. Feel the texture and form of brick and mortar, closely examine wood, plaster, stone, glass and peeling paint. But remember to paint what you see, not what you know.

In this chapter you will see how techniques such as splattering, scraping, scratching and color lifting can be used to augment your painting medium and to produce textures that add character to your paintings of buildings.

Distance Changes Texture

When you are standing close to a public building, house or any kind of structure made from building materials, the various textures are strong and detailed, but as you move farther away the textures begin to blend, gradually losing the detail and then becoming simply shapes and patterns.

If you are painting a cityscape with large groupings of buildings and houses, it is best to look for the shapes and patterns rather than trying to paint each and every structure. The foreground structures are where the detail and individual textures are seen. Moving into the background, the buildings become a series of shapes created by rooftops, facades and angles that become texture that is not subject specific.

Try this exercise to help you focus on shapes and patterns: Pick a subject or a scene such as the city street at right and, with a dry brush, quickly paint in the shapes and patterns of the structures. Remember to keep it simple, emphasizing the *lines* and *shapes*. When this is dry, wash the entire paper with a light background wash; the color is your choice. The idea is to quickly capture whatever is most prominent.

Marbleworks, L.I., NY by John Pellew illustrates the importance of seeing shapes. The textures found in this old building on the Long Island side of the East River are presented as shapes and cast shadows with drybrush to pick up the rough texture of the stone. The depth of the doorway draws the viewer through the painting into a series of abstract shapes depicting the distant skyline. The paper's surface and Pellew's light touch have captured texture, light and form in a clean, uncluttered way.

Step 1
Using the dry-brush technique in any water-based medium, quickly paint the most prominent shapes and lines. Work quickly, letting the drybrush supply the texture.

Step 2
Once you have completed the texture and basic forms, make sure everything is dry. Then apply a light wash over the entire surface. This will soften some of the edges, unify the shapes, and reveal the patterns.

Marbleworks, L.I., NY
John C. Pellew
Watercolor
18" × 24"

Pellew's trademark simplicity provides a fresh quality to his subjects. Transparent washes, design elements, and fine drybrush technique capture the texture, form and character of this colorful old building.

In *Outskirts* Henry M. Gasser used a two-toned imprimatura to establish base color and texture and to create softness and warmth in the finished work.

The top half of the canvas was covered with blue-green and the bottom half with red-toned burnt sienna. Gasser then proceeded to build up the foreground shapes with loose applications of color allowing the imprimatura to remain visible where the colors came together. The buildings were handled in much the same way to ensure the same smooth texture. The grouping of buildings in the right middle ground and background creates interesting texture with its angles and shapes.

Outskirts

Henry M. Gasser
Oil
20″ × 28″

Gasser developed a consistency of texture throughout the foreground by allowing areas of the burnt sienna and red underpainting to show through and become part of the final work. The texture and color of the wooden siding are enhanced by details and by areas of the imprimatura showing through wherever the overpainting is thinly applied.

Detail

The brick texture on the houses in the distant middle ground is rendered as shapes that are suggested simply with color and brushwork.

Carving Shapes With Texture

If you have ever traveled in the Southwest, then the rounded soft corners of adobe walls and buildings should be familiar to you.

In *Mother and Child*, Carroll Collier has captured the muted earth tones and smooth feel of adobe with his gentle painting style.

The deeply inset doors and windows with their rounded edges and smooth curves, the outdoor ovens in the courtyard—all blend into the natural surroundings. This creates a harmony of shape, texture and color that is characteristic of the area.

In direct contrast, *Plaka Ruins*, by Edgar A. Whitney, has sharp, angular strokes and texture. Whitney's use of drybrush, strong horizontal and vertical strokes, in combination with a rough surface have provided the right ingredients for a crisp and lively textured painting. The stone buildings and ruins are carved from the paper's surface with the darks and strong calligraphy in the background and foreground. Light, shadow and light tonal washes supply just the right amount of finishing texture and contrast.

Mother and Child
Carroll Collier
Oil
9" × 12"

Allowing the darker underpainting to show through, Collier captured the uneven surface texture of adobe with thinned applications of earth tones and the rough weave of the canvas.

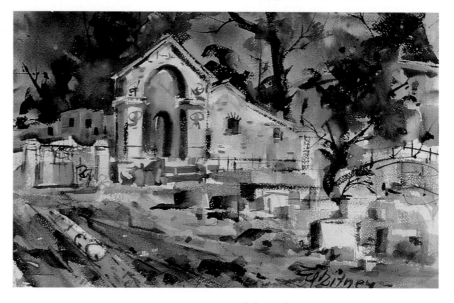

Plaka Ruins
Edgar A. Whitney
Watercolor
14" × 20"

Whitney's fluid technique is used simply and effectively to carve the stone buildings and ruins out of the paper's surface with a traditional light to dark watercolor method. His bold purposeful lines and strokes suggest form, detail and texture.

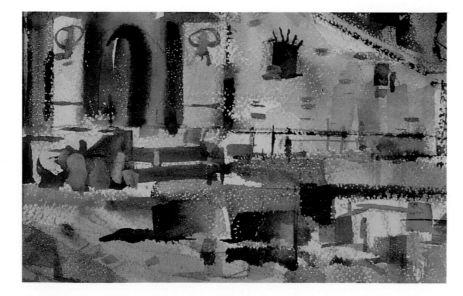

Detail
Whitney's excellent use of the paper's rough surface, light toning washes, drybrush texture and bold calligraphic strokes keep his work lively and interesting.

Time and Weather

Time and weather conditions play an important role in creating old, weathered textures, especially wood left untended. Ultraviolet rays are responsible for bleaching and fading color and causing wood to dry, shrink and crack. Moisture can soften and rot wood, causing it to sag and crumble. These factors along with items like broken glass and crumbling foundations are what attract artists and give character to the subject.

The house in *Memories* has certainly been influenced by time and the elements. This painting was approached with a limited palette to stress the sense of abandonment. Very thin washes of raw umber and Hooker's green were used to put a light stain on the paper and give the wood a feeling of drying and cracking.

The Colors of White

The white side of a house is never just white but a combination of color tints running from blue-green to orange. The values and colors in a photograph are always wrong. When you work from a photograph you must make changes based on experience to tell what would be happening in the shadows if you were painting on location.

An Old House
Carroll Collier
Oil
18″ × 24″
Photo courtesy Baker Gallery,
Lubbock, Texas

The colors of white here range from dark, low-intensity violets and ochres to light greens, blues and pinks.

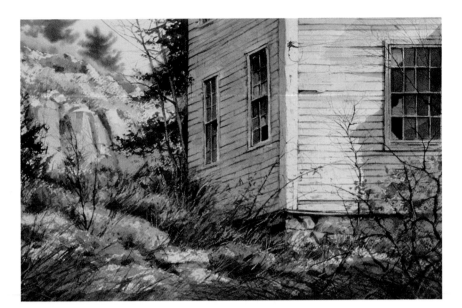

Memories
David Band
Watercolor
8″ × 12″
Collection of Greg and Jackie Hoegger

Light washes of Hooker's green and raw umber were used to develop the tone and texture of the landscape and house. Burnt sienna and Payne's gray were used to complete the landscape and scumble the dry texture of the grass.

The uneven lines, nail holes and shadows convey the texture and condition of the wood siding. A mixture of Payne's gray and raw umber was used to paint the windows. Blotting them quickly with a paper towel left the grimy, stained look of old glass. To finish the windows, undiluted Payne's gray was used to create the dark holes of missing and broken glass.

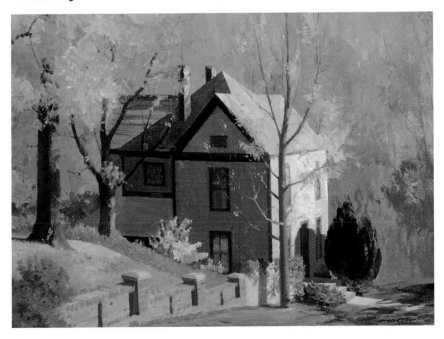

Building Surface Textures

Usually when we think about building a painting surface with texture, oil and acrylic are the first mediums we think of. Yet you can do this with watercolor as well.

Texturing Watercolor Paper.

The first and most common way is to raise the dry paper's surface by scraping with a razor blade. With heavy paper, first soak the surface and, before it is dry, take the razor and "push" the softened pulp into raised patterns. When it dries you will have a much rougher surface that will provide unusual textures, particularly good for architectural subjects in stone.

Using Crayons.

The wax and grease in crayons resist fluids un-less the marks are worked repeatedly with paint. Then the grease breaks down and some areas will take the paint. Crayon can be used lightly or in a layered fashion, depending on what textural effect you desire. Crayon will affect colors differently depending on the staining ability of the pigment, but in any case, interesting broken textures can be achieved this way. If an area in a dry painting is flat and uninteresting, both crayon and pastel are excellent for adding texture and interest.

Combining Ink and Watercolor.

Backyard, (at right), by Henry M. Gasser, has a fair amount of texture in the surfaces of the foreground wood and brick. The strong light and distance soften the textures in the background. The fine dark lines and splatter texture were done with waterproof pen and ink into a moist surface to soften and provide a variety of line. Once the ink and paper were dry the color washes were applied without disturbing the ink texture.

Ink now comes in many colors and as long as it is waterproof, it will work well for developing texture with underpainting and detail. *Stone Steps*, (below), by Henry M. Gasser, was done using brown ink for the preliminary drawing, and ink wash for the textural undertoning. When this was dry, watercolor was applied to finish the texture and color.

The Stone Steps
Henry M. Gasser
Watercolor
22" × 15"

Brown waterproof ink was used for the preliminary drawing with an ink wash to develop the textural undertone. Once this was completed, watercolor was used for the finishing texture, detail and color.

Detail
This close-up shows the additional texture produced from several layered washes of pure watercolor and fine splattering.

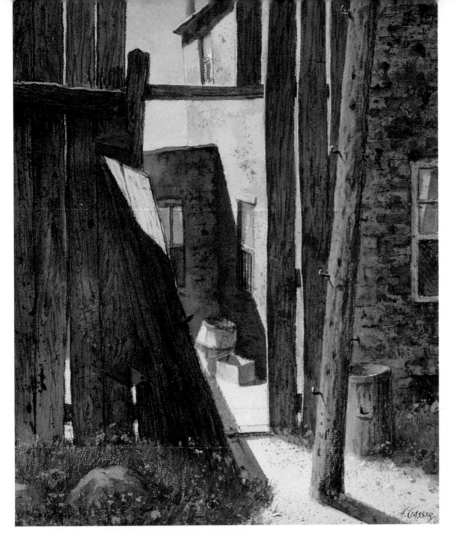

Backyard
Henry M. Gasser
Watercolor
14″ × 11″

In *Backyard*, texture seems to be as prominent as color and design. In fact, the preliminary drawing was done with brown waterproof ink on moist paper so the ink could bleed and soften the lines. Watercolor was used after the ink dried. This preliminary use of ink for texture is similar to the Old Masters' use of a monotone underpainting for value.

Summertime, Greece
Henry M. Gasser
Watercolor
12″ × 18″

Black and brown inks were used to establish the preliminary texture in this watercolor. After a thin wash of Davy's gray was added, a razor blade was used to scrape and texture the large stones in the archway and the cornerstones of the wall.

Demonstration
Brick, Plaster, Broken Glass

Remnants is a small watercolor study in the weathered and decaying textures of brick, plaster and old glass. I used the dry-brush technique for all of the textures in this painting.

The windows were painted with Payne's gray and burnt sienna, then quickly lightened by blotting with a paper towel. When they were completely dry, the effect of missing and broken glass was accomplished by reducing the light glass areas with an application of undiluted Payne's gray.

After the grassy areas were completed, a light splattering of burnt sienna was used for the final texture in the brick and plaster walls.

Remnants
David Band
Watercolor
6" × 10"

Step 1
Thin layers of Naples yellow and burnt sienna are scumbled randomly for the base texture of the old plaster wall to capture the uneven surface and bleached color. The bricks are then started with broken lines of thinned burnt sienna using a flat-end no. 2 white sable brush.

Step 2
Additional layering and texture is applied to the bricks with drybrush and a splattering of burnt sienna and Thalo blue. Using burnt sienna and Payne's gray, a no. 2 sable flat brush is skipped along the surface to create the broken texture of old brick. This is followed by a thinned mixture of Naples yellow and Thalo blue, scumbled lightly over the wall for color and texture.

Step 3

The windows are painted with a mixture of Payne's gray and burnt sienna then quickly blotted with a paper towel to give the look of old glass. When they are dry, strong Payne's gray is applied to reduce the light areas to create the effect of shapes of broken and missing glass.

Step 4

In the final stage additional texture is added by scumbling and splattering with burnt sienna and a touch of Thalo blue. The grass is also painted dry with burnt sienna and Payne's gray, detailed with a mixture of Naples yellow and Chinese white to pick up the broken light.

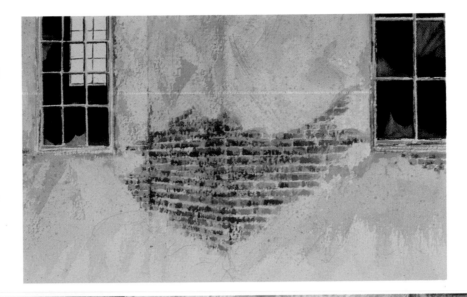

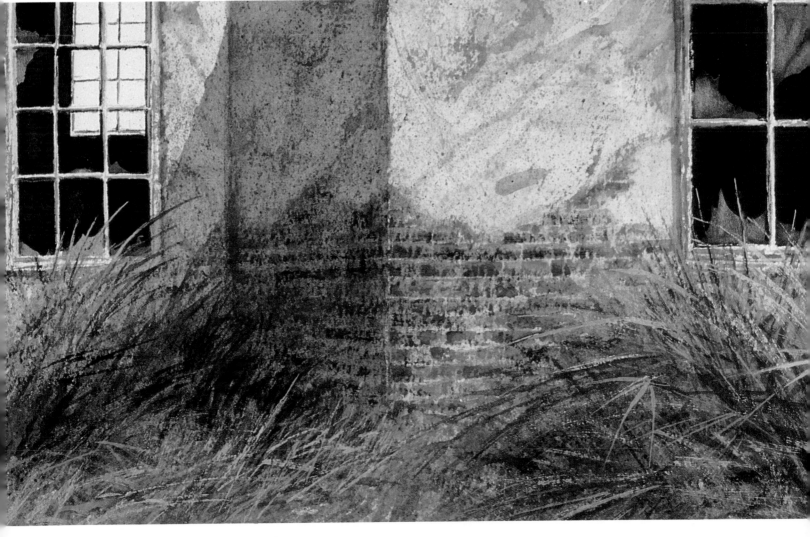

Demonstration
Smooth Textures in Oil

Carroll Collier's oil painting *Summer Shade* is another example of his smooth and consistent style. He always begins by preparing the canvas with a "textural white" mixed with a little turpentine. This gives him a textured, built-up surface to start with. To create this base he uses a 2-inch brush with loose, haphazard strokes. When it is dry, he draws his subject in with soft charcoal. Values are then established with the approximate colors for each area mixed with turpentine.

Seeing and interpreting the textures of buildings, houses and other structures demands a sharp eye and experience. This is acquired with time and practice. Collier spends a lot of time observing and painting outdoors. He generally paints at least a full-color study on location and many times completes his finished painting outdoors as well.

Summer Shade
Carroll Collier
Oil
16" × 24"

Step 1
The canvas is covered with textural white mixed with a little turpentine. Then the subject is drawn in charcoal with the dust blown away, leaving only a faint image as a guide.

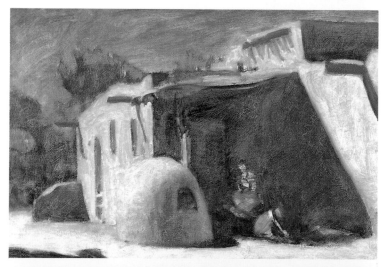

Step 2
Turpentine washes with the appropriate colors are laid in for each area: ultramarine and Thalo blue in the sky, cadmium red deep and cadmium yellow deep for the adobe, with a mixture of Thalo blue, cadmium yellow, cadmium red deep and some deep violet for the shadows.

Step 3
Heavier paint with a painting medium is used to refine the colors and values.

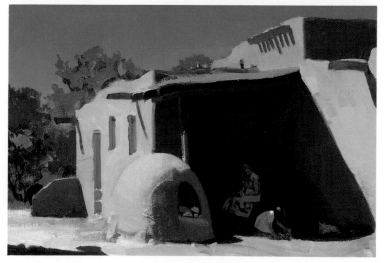

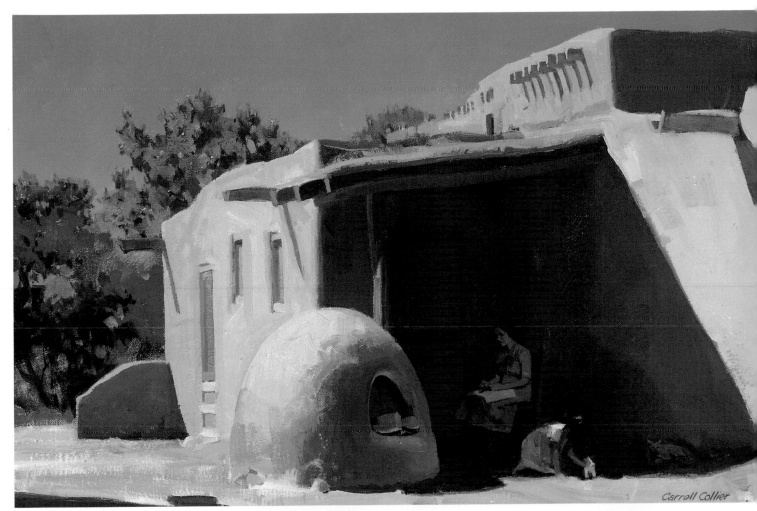

Carroll Collier

Step 4
This stage further refines texture and color. The natural color of adobe has an orange tint that Collier achieves by using Acra red with cadmium yellow deep. This is finished with a light blue tint scumbled over the surface for color and interest.

Detail
In this close-up you can see the process of building the adobe texture. The paint is applied spontaneously but each stroke is purposeful and carefully considered.

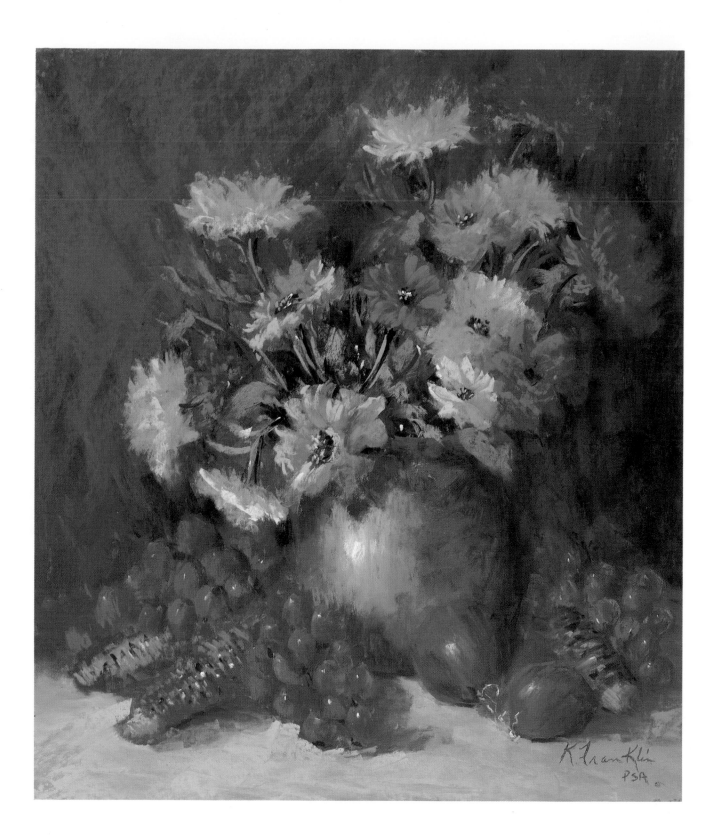

Chapter Nine
Still Life

Mention still life and instantly a mental image of fruit, flowers and an assortment of jugs, bowls and roses comes to mind. But actually just about anything can be a suitable subject for a still life painting. Attics, workshops, closets and barns are excellent sources for interesting and unusual objects with varied textures. However, the choice of objects is only the first step in still life painting. You can do an interesting study of objects, but what causes a still life to touch a viewer's emotions?

It is *intimacy*. Still lifes are close-ups of personal, familiar places and objects of our own choosing. You can take whatever amount of time you desire to paint them because they don't depend on external conditions, and they are, start to finish, your creations.

You have complete control of color, subject, lighting and compositional arrangement. Don't forget that the background is an integral part of the setup and painting. It should be well thought out, not just a flat afterthought. Too often the texture and character of the background are overlooked when the background should be an essential link between the subject and atmosphere of the painting.

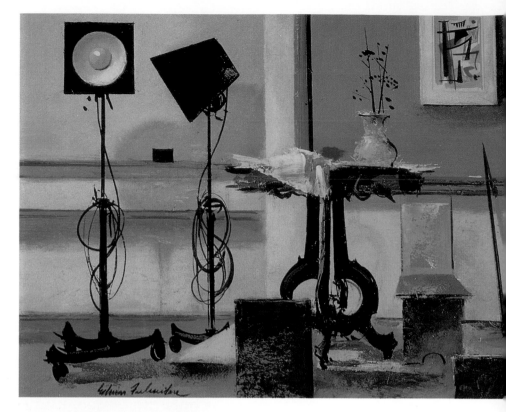

Familiar Objects and Places

The sense of intimacy that is projected when there is a special connection between artist and subject is evident in Edwin Fulwider's small oil painting *Studio Corner*. The subject is a drawing studio in the old art building at Miami University, Oxford, Ohio, as Fulwider saw it some years ago when he first taught there.

After completing a session with a drawing class, he happened to glance at this corner as he was leaving and was impressed by the exciting arrangement of shapes, line, color and form. He quickly made a thumbnail sketch of the arrangement and painted the still life in his studio that afternoon.

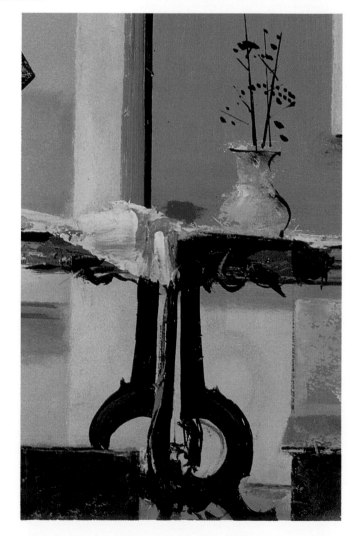

Studio Corner
Edwin Fulwider
Oil
8″ × 10″

Fulwider's use of a homemade damar varnish to hasten the drying time of the oil paints made it possible for the linear work to be applied almost immediately after the flat areas.

The damar varnish is made by wrapping raw gum damar crystals in cheese cloth drawn together at the top as a bag. This is suspended in a small jar of turpentine. Over a period of time the damar crystals dissolve in the turpentine and the resulting thick solution is a fast-drying varnish that is absolutely compatible with oil paint. Experience teaches the proper quantity of dry crystal and turpentine to obtain the desired viscosity.

Detail
This close-up shows Fulwider's use of the fast-drying quality of the damar varnish to produce an interesting variety of textures. Using both flat layers of color and varied calligraphic strokes, he has unified the complexity of objects and textures into an exciting composition.

Fulwider feels that doing the painting in his studio helped him create a more interesting painting by enabling him to develop patterns that were compatible with the composition, rather than feeling bound to copy the subject for the sake of complete fidelity. But Fulwider stresses that an essential aspect of *Studio Corner* is his thorough familiarity with the elements in the painting because he used them in his classwork daily.

Fulwider also has a longstanding relationship with trains and railroad subjects that allows him to paint these subjects with intimate knowledge. A conversation with a railroad freight conductor one winter night at a small interchange point on the Milwaukee Railroad near Cedar Falls, Washington, was the inspiration for his oil painting *Caboose Window — Moonlight*. The conversation began with a discussion of the harsh winter weather.

This led to the conductor's tale of one of his winter weather experiences on the railroad. The streamliner that ran from Chicago to Seattle had stalled and was frozen in one winter night in heavy drifts.

Hundreds of passengers were in extreme danger. All railroad personnel including the railroader narrating this story were called out. After two exhausting days and nights the train was dug out and the passengers were rescued. In spite of overwhelming fatigue, this railroader could not go to sleep because he was so overcome by the beauty of the moonlit winter night. The sensitivity of this hardworking railroader was the inspiration for Fulwider's still life.

Caboose Window — Moonlight
Edwin Fulwider
Oil
16″ × 14″

This painting was executed on a gessoed panel with strokes of average paint thickness. Once the gesso was dry, numerous glazes of thinned color were applied. In this way color was built up in transparent layers over the base color. This process creates color and texture that is not obtainable by mixing the individual colors together and applying it as a single mix. The light refracting through the layers of glaze creates a ''stained glass'' effect caused by the physical depth of the transparent layers of paint. This glazing process was used to paint the hard surface of the lantern's metal and glass, the worn texture of the leather glove, and the smooth texture of the tightly woven handkerchief.

Apple
David Band
Watercolor
9″ × 6″

The background was painted in two stages. First, the wet stage was begun by dampening the paper with a sponge. A wash of burnt sienna, yellow ochre and Thalo blue is applied quickly with a 1-inch wash brush. To emphasize the light source, graded washes of Payne's gray and Thalo blue were applied from left to right, gradually lightening toward the light source on the right. This was done as often as required to produce the softness of the fading light and deep shadow.

With the atmosphere established, the next step was the detail and texturing of the wall. For this, a series of graded splatter applications was done with burnt sienna and Payne's gray. Once this was dry the remainder of texture was accomplished with drybrush and scumbling followed by a final wash of a thin mixture of Thalo blue and burnt sienna.

Because of the fine detail and texture in the wall, the apple is presented with much simpler color and form. Detail was reduced to a minimum with a few strokes of yellow-green and Chinese white for highlight.

Background Textures

When I paint a still life, I am often preoccupied with the background. In fact, sometimes the background becomes the subject and the objects are used to complement the background. I'm fascinated by the effects of indirect light on the texture of a stone or plaster wall and

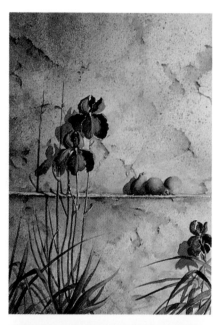

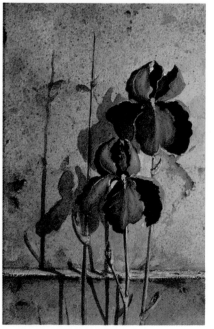

how reflective color and cast shadows change the texture. In the two small watercolor still lifes *Apple* and *Iris and Pears*, I used the same area of a decaying plaster wall with a shallow shelf for a background.

In both paintings the objects are rendered with less detail than the background, placing the emphasis on color and form. In this way competition between background and objects is eliminated.

Iris and Pears
David Band
Watercolor
12″ × 9″
Collection of James and Laurette McDonald

The entire background was done wet-in-wet using burnt sienna and yellow ochre for the base color. While the paper still had moisture, additional color and texture were added with burnt sienna and Payne's gray. After the paper dried the next step of creating areas of missing plaster was done with a light mixture of burnt sienna and Thalo blue. Before those areas dried, burnt sienna was dropped into the edge of the depression for depth and strengthening of the lighting effect. Additional texture was added with splatter, scumbling and drybrush. After each application of texture a light wash of burnt sienna was applied in a glazing method to enrich the color and texture.

Detail
Simpler texture but contrasting color and form help make the subject compatible with the detailed texture of the background.

Demonstration
Painting a Shiny Surface

Tony Saladino does not finish his paintings with a lot of detail. He is mainly interested in shapes and color contrast. He is able to establish very believable textures with just a few brushstrokes.

Still Life
Tony Saladino
Oil
20″ × 28″

Step 1
After defining shapes and establishing placement with soft charcoal using a heavy line, Saladino decides that his painting should be predominately warm. He blocks in the jugs and foreground with fairly flat warm colors, concentrating on developing form with shadow areas.

Step 2
He lays in the local color of the apples, keeping it much more intense than any of the previous colors in the painting. He strengthens the forms of the jugs, adding some dull highlights.

Step 3
The completed painting shows an obvious contrast in texture between the jugs and the apples. This is accomplished with few strokes. The texture of the rougher, matte surface of the jugs is conveyed by the less intense color, by the smooth transition between tones on the rounded form, and by the not-so-white white of the highlights.

In contrast, the shiny, smooth surface of the apples is revealed by the bright, intense color and especially by the bright white highlights that are the brightest lights in the painting.

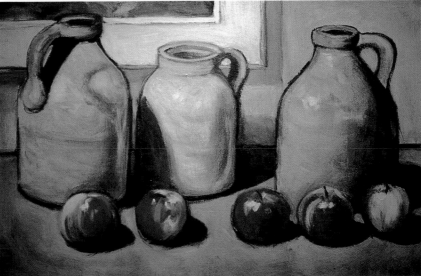

Demonstration
Simplifying Complex Textures

Studying the pastel paintings of Kaye Franklin, one is struck by the sense of unity in her work. Her colors are vibrant and alive with texture showing a sensitive understanding of and closeness to the subject. In her painting *Spring Garden* there is a complexity of texture that results in a bounty of light and color. The rhythm of dark-to-light contrast is underscored by her use of hard and soft strokes that come together into a vivid image.

Franklin chose a sanded pastel paper for her demonstration painting *Apples and Plums*. Cool tones established the darks and basic composition. She then proceeded with a turpentine wash for the underpainting, being careful to keep the shapes and values intact.

Staying away from detail, she then strengthened darks and included more color before using soft pastel to complete the work with highlights and detail.

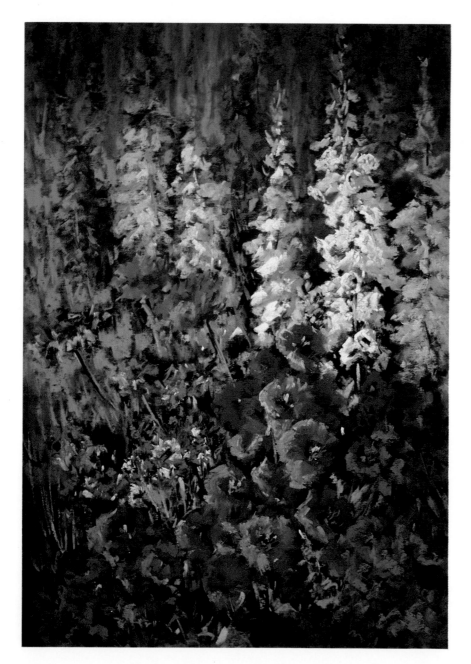

Spring Garden
Kaye Franklin
Pastel
14" × 11"

After establishing strong forms with an underpainting of turpentine wash, Franklin gradually built her color base with a pattern of heavy and light strokes. Careful not to completely cover the underlying darks, she developed atmosphere by the use of hard and soft edges. Dramatic illumination was achieved with heavy pressure on the final detail and texture.

Apples and Plums
Kaye Franklin
Pastel
13″ × 20″

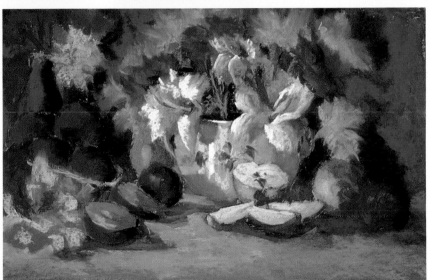

Step 1
Cool tones are applied to the sanded paper to establish the main shapes. For this first series of block-ins Franklin uses hard pastel with very light pressure. In this stage special effort is made to ensure that the cast shadows are correct.

Step 2
Using a stiff bristle brush, a turpentine wash is applied to create a working underpainting without removing the shapes and values. Care must be taken to keep the surface from becoming muddy.

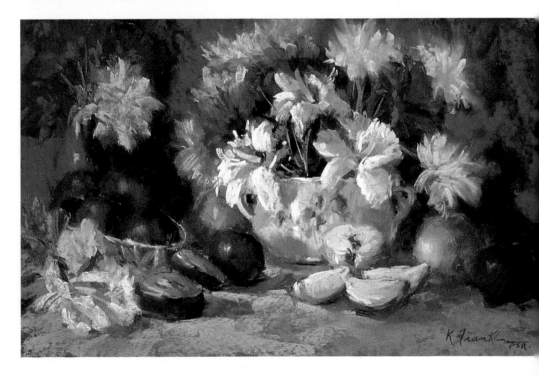

Step 3
After making sure the wash is completely dry, more color is added to reinforce the darks. More intense local color with minimal detail is added while the object forms are strengthened with a full range of values.

Step 4
At this stage everything is brought together with soft pastel. Light areas are used to lead the viewer through the painting. The final details are applied with harder pressure including highlights on the glass and porcelain.

Demonstration
Texturing With Hard and Soft Pastels

Kaye Franklin used a selection of complementary colors on sanded pastel paper to capture a sense of warmth and tranquility in this charming pastel painting *Sunflowers*. As with most of her work, she started with a turpentine wash underpainting using a bristle brush. When this was dry she added new shapes over the wash and strengthened them with local color (*local color* refers to the actual color of the object). The entire painting was gradually developed from dark to light for definition of form and composition. Franklin's extensive use of underpainting, middle tones and darks gives her work a full range of depth, texture and color.

Sunflowers
Kaye Franklin
Pastel
9″ × 13″

Step 1
Hard pastels and light pressure are used to lay in the darks and local color.

Step 2
The underpainting is done with a turpentine wash and a bristle brush for the dark shapes. Then the brush is cleaned and the lighter shapes are washed in. When the wash is dry more color is added.

Step 3

At this stage new shapes are introduced over the dry wash. Franklin is careful not to be too repetitive in her choice of shapes. Additional local color is added and the dark wash is examined for proper value and shape before the lights on the flowers, background and copper kettle are put in.

Step 4

Now all of the elements are brought together with soft pastel and hard pressure for stronger lights and cast shadows. The texture of the copper kettle is achieved by first using dark violet for the shadow, then using raw umber, a touch of green and a lighter value for the halftone. The local color is a red-orange with a gray tone and a lighter value grayed-orange. The final highlights are composed of white with a touch of yellow.

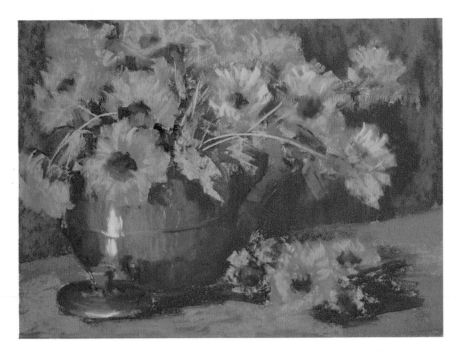

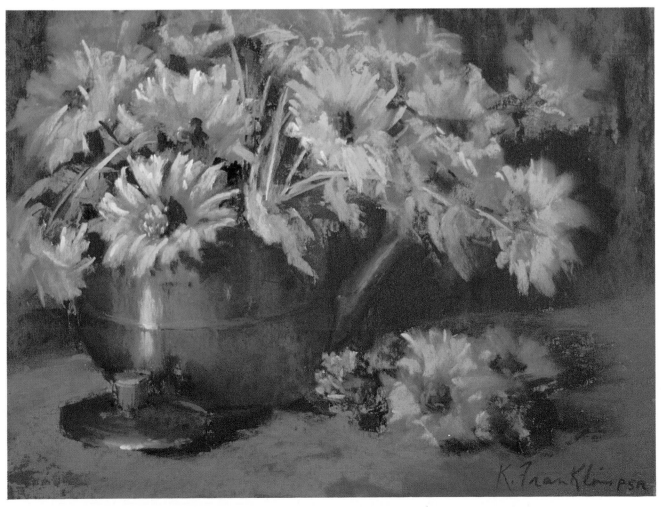

Chapter Ten
Mood and Atmosphere

Atmosphere is that mysterious, elusive quality that sets the mood in a painting. In this chapter we will examine ways that texture can be used to create atmosphere, and therefore affect the emotional content of a painting.

Atmosphere and mood, though mysterious, are determined mainly by the way color, light and texture are used. For example, fog is something that provides atmosphere. Fog is a combination of light, muted color with a semiopaque smooth texture that softens and obscures detail and form. It is these elements of texture and color that set the mood and provide atmosphere.

Another way to show atmospheric texture is by using light. Light can create depth, by softening the texture in a distant landscape, or communicate a mysterious atmosphere with the shadows and hazy textures of moonlight.

The action and movement of brushstroke textures also affect the mood of a painting. A peaceful landscape that has smooth blended textures painted with soft, flowing strokes and subtle movement creates a serene mood and a pleasant atmosphere. You could say that mood is the texture of atmosphere.

Light and Texture

The combination of light and texture mixed with color and technique forms the basis for mood and atmosphere.

Tony Saladino uses these elements in a highly energized atmosphere of bold strokes, action, texture and color. His oil painting *Landscape With Snow* embodies these qualities with its strong textural sense and fading winter light. He used a cool, soft background and warm reds and yellows in the foreground to capture a mood of seasonal change. Additional depth and atmosphere were achieved with color perspective by using the warmest whites in the foreground.

Desert Landscape has a completely different atmosphere of warm, hazy light done with a different medium and technique.

New Mexico Idyll is a watercolor that has the deep space so common in Southwest landscapes. The intense light extends the horizon by softening and shaping the expanse of rolling hills and valleys. The controlled wet-in-wet technique was used to develop the soft, low contrast cloud formations. By pushing them into the background, they have the illusion of going beyond the horizon which strengthens the sense of deep space. The sharp contrasts of light and shadow in the buildings and trees in the foreground provide a mid-ground focal point for depth comparison.

The quiet and peaceful atmosphere in *Gentle River* (on page 122) is the result of soft, low-contrast texture. The background hills have a minimum of definition. The illusion of details is accomplished by gentle contrasts within the colors. Throughout this painting, the emphasis on a consistent style of texture produced a peaceful atmosphere that is reflective of the mood.

Desert Landscape
Tony Saladino
Acrylic
72″ × 54″

To promote a sense of distance, Saladino used color perspective to create atmosphere. He used a splatter technique with liquid acrylics to build the surface and content. By using a graduated size scale of splatter patterns from large in the fore- and midground to small with less intense colors in the background, he conveys a deeper sense of open space.

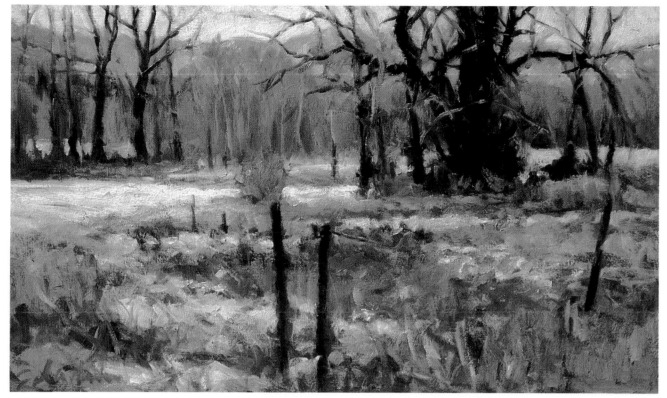

Landscape With Snow
Tony Saladino
Oil
24″ × 40″

The warm whites of the foreground with the blended blue-grays of the shadows and distant landscape are used to convey the natural stillness and peaceful atmosphere of the winter woods.

New Mexico Idyll
David Band
Watercolor
9″ × 12″
Collection of Robby Vestal

The soft cloud formations were done with controlled wet-in-wet using light applications of Thalo blue and a very thin wash of alizarin crimson for tone. The land areas are layers of yellow ochre for the base color and Hooker's green, burnt sienna and Payne's gray for detail and texture. The sharp contrast of the foreground and middle ground against the soft background enhances the sense of deep space with a light, airy atmosphere.

Gentle River
David Band
Watercolor
14" × 10"

The peaceful atmosphere in this painting is a reflection of the soft textures used in all elements of the landscape and water. The base color for the hills, flatland and foliage is yellow ochre with wet applications of burnt sienna, Hooker's green and Payne's gray to give subtle shape and detail. The trees and bushes by the river's edge were done with several layers of Payne's gray, Hooker's green and yellow worked in with a "rubbing" stroke with a bristle brush. This "rubbing" stroke gives the foliage a soft yet very dense appearance.

The gentle movement in the river was handled in a similar fashion by laying in several flat washes of a very thin mixture of Payne's gray and Thalo blue. When the wash was dry, it was covered with a semi-opaque wash of Naples yellow. The gentle ripples and subtle movement in the water were done with sweeping strokes. Another wash of very thin Naples yellow was applied with downward strokes to enhance the illusion of moving water.

Scranton Express
Kent Day Coes
Watercolor
21″ × 29″

Kent Day Coes's use of dramatic lighting, smooth flat texture and powerful dark imagery in his watercolor *Scranton Express* presents a painting rich with drama and atmosphere. The interior lights and indirect night light transition into strong patterns of light and shadow capturing the mood of the weary commuters arriving home with their holiday purchases.

Coes's use of deep, rich velvetlike texture permeates the painting with a dense, intimate atmosphere.

Coes's effective use of dramatic lighting, powerful imagery, and a rich velvetlike texture creates a unique emotional quality and intimate atmosphere.

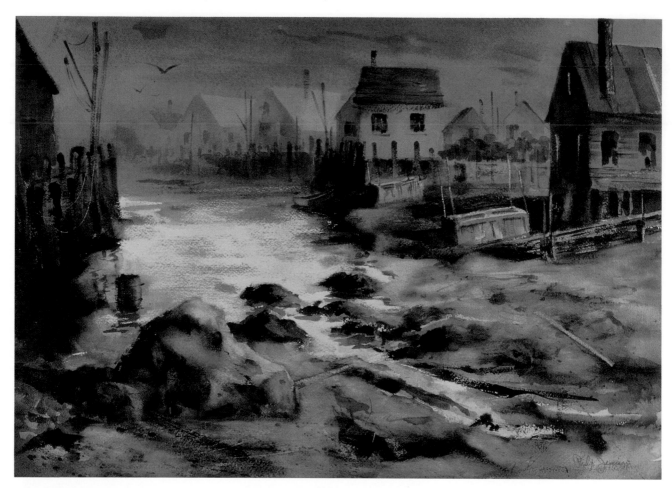

Weather Texture

Fog and mist are two elements of weather that have a profound effect on atmosphere. They soften and diffuse texture, color and depth. Fog gives a sense of depth by causing shapes to recede into the background and, if it is dense enough, they will completely disappear, giving the illusion of endless space.

In *Vinalhaven Marine*, a watercolor by Philip Jamison, the use of gray-brown earth tones and soft, flat textures gives the work a somber mood and subdued atmosphere. His use of distant fog provides a sense of deep space by reducing the buildings to a field of obscured features and minimal detail.

The wet, slick streets and misty silhouettes of distant skyscrapers set the mood and provide the atmosphere for John C. Pellew's watercolor *Rainy Day*. There are dramatic contrasts of subject and space which enhance the composition with a sense of depth and atmospheric quality. Pellew uses both hard- and soft-edge texture to capture the action of changing reflections that is created by movement in the light and foreground figures.

The illusion of detail and Pellew's attention to mass and form are used to punctuate the effects of soft diffused light so characteristic of the low ceiling atmosphere of mist and rain.

Vinalhaven Marine
Philip Jamison
Watercolor
22″ × 30″

The dreary subdued atmosphere in this painting is conveyed through Jamison's use of subtle muted color, soft textures and diffused light to create the spatial effects of distant fog.

Rainy Day
John C. Pellew
Watercolor
20″ × 28″

The illusion of detail, misty silhouettes of distant buildings and sharply contrasting figures and shapes is used to capture the atmosphere and feeling of an overcast and rainy day.

Detail
Pellew's use of drybrush captures the spotty reflected light texture that is seen in wet surfaces.

Swamp Angel
Roy M. Mason
Watercolor
21" × 30"

The strong sense of atmosphere in Mason's work is the result of distinct detail and texture in the foreground and soft, blended background textures that gently silhouette against the sky.

Roy M. Mason was a self-taught painter of the sporting scene and was an avid hunter and fisherman. It is said that he lived to paint and did so every day except Sunday. He would paint in the morning and do his hunting and fishing in the afternoon. His passion for the outdoors gave him a keen understanding of atmosphere and space which became a standard of his work. It also enabled him to focus on the fundamentals of his subject and eliminate unnecessary detail, as in his watercolor *Swamp Angel*. The details and subject are rooted firmly in the foreground which gives the illusion of greater depth in the background of tree masses and cloud forms that are engulfed in the morning mist. This soft, indistinct background of quiet colors creates an overwhelming sense of space and atmosphere.

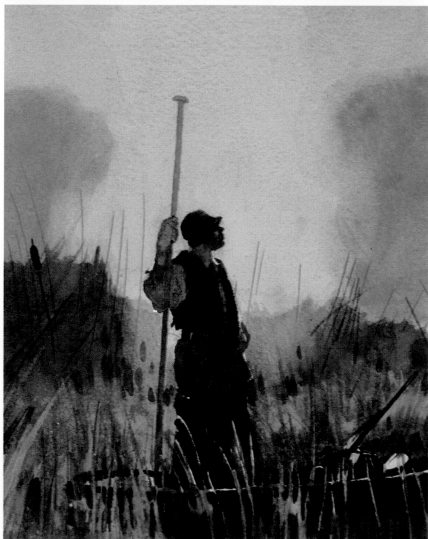

Detail

Demonstration
Filtered Morning Light

Misty Morning, a small pastel by Kaye Franklin, presents an atmosphere enriched by the spatial qualities and low-contrast texture that are characteristic of early morning mist. The soft, filtered light bathes the landscape in a warm, undisturbed tranquility.

Misty Morning
Kaye Franklin
Pastel on sanded paper
11" × 14"

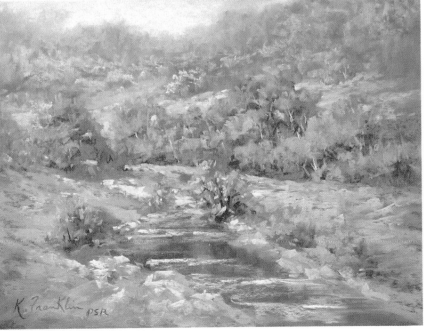

Step 1
A very thin application of ivory black and turpentine is used to tone the sanded surface of the paper. The darks are then added with very little contrast.

Step 2
Local color is added including a very light pink and a gray of equal value.

Step 3
Cool colors from the same family as the local color, only lighter in value, are used to add some lights.

Step 4
It all comes together with detail and contrast. The atmosphere is created by dragging a gray-blue over the background trees and adding higher value, cool lights to the water.

Demonstration
Combining Acrylics and Oils

Landscape With Wildflowers by Tony Saladino is oil painted over acrylic. Saladino feels this allows him to expand the natural quality of oils.

He began by doing a rough charcoal sketch of the subject, then used acrylic to block in the tree forms, clouds and foreground.

Once he was satisfied with the acrylic phase, Saladino switched to oils to refine the composition.

When he was satisfied with the composition, he relied on bold brushwork for the foreground, using directional strokes to develop texture and form. To emphasize the thickness of the atmosphere, Saladino painted the low sky area with a soft, hazy texture.

Landscape With Wildflowers
Tony Saladino
Oil and acrylic
18" × 26"

Step 1
A rough charcoal sketch of the composition is completed.

Step 2
With acrylics, Saladino uses Hooker's green to block in the tree masses, and a mixture of titanium white and Thalo blue for the sky nearest the horizon. Ultramarine blue mixed with titanium white is used for the sky color away from the horizon.

Step 3
In this stage Saladino applies some blue for the distant hills and paints some base color for the foreground with warm earth tones.

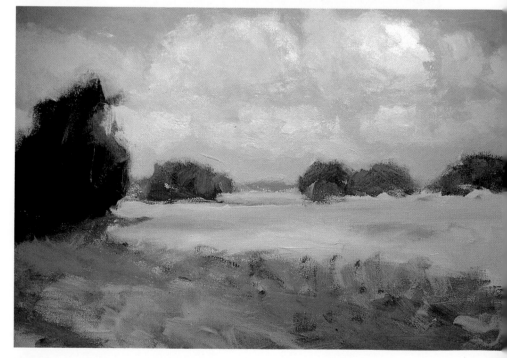

Step 4
Volume is added to the clouds by defining areas with highlights and shadows. Additional detail and texture are applied to refine the foreground areas.

Step 5

Saladino begins to use oils. He makes some compositional changes by moving or adding trees to establish balance and harmony.

Step 6

Bold brushwork and strong directional strokes with oil paint are used to emphasize form. Using purer colors in the foreground than those in the middle ground, he is able to make the foreground advance, which strengthens the sense of deep space. To create a thickness in the atmosphere, he uses a hazy texture in the low sky area.

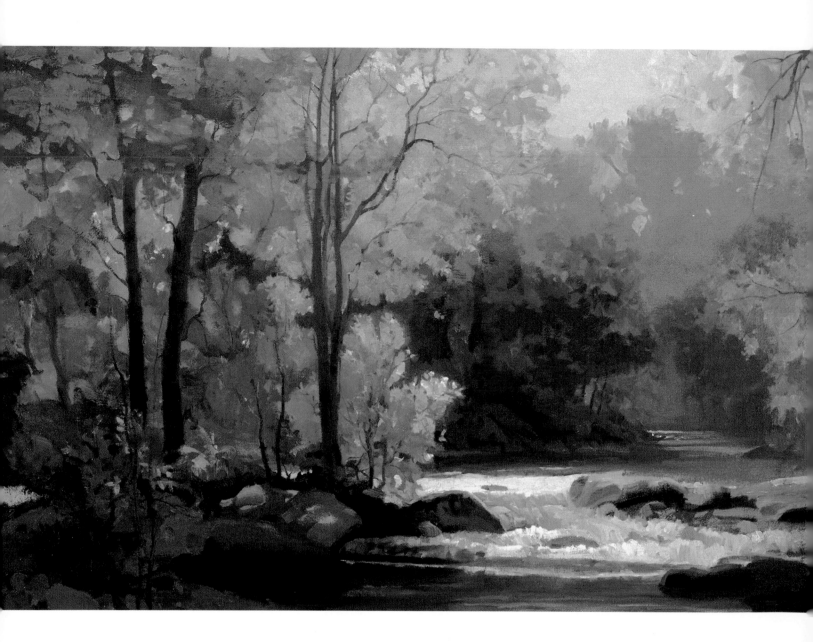

Conclusion

Rapid Stream
Carroll Collier
Oil
24″ × 36″
Photo courtesy Baker Gallery,
Lubbock, Texas

Collier's use of soft and hard edged brush-work provides a believability and depth to this painting with a variety of textures, from the action of the shallow falls to the gentle layering of the background foliage.

Painting is a visual conversation of ideas, style and emotion that is carried on between the artist and subject. It is full of questions that can only be answered by time, patience and practice. Texture is the answer for many of those questions and it can make the dialogue flow. Like most answers that require research and time to produce, the same holds true for texture. It requires seeing, understanding and practice.

What has been presented in this book are some of the ways texture has been seen and used by artists like you. I encourage you to examine the way you see, practice what you learn, and let *your* personality create your style. If you do these things, your work will be a meaningful conversation that never ends with an unanswered question.

—*David M. Band*

The Artists

David M. Band

David Band has devoted the majority of his life to art as a student, practicing artist, teacher and collector. He considers himself to be primarily self-taught even though he received an art scholarship to the University of Maine. His formal art training ended when he entered the United States Air Force in 1966, but as luck would have it, he was eventually assigned to the School of Health Care Sciences as a medical illustrator which afforded him the opportunity to continue his education and develop his skills. After leaving the Air Force his interests in collecting and conservation of works on paper developed into a business along with custom framing.

Band feels that the preservation of fine art is as important as the creation of it and more artists should be aware of the process.

With watercolor as his medium of choice, Band also works in oil and acrylics from large abstracts to miniatures of all subjects. Band has taught at the Wichita Falls Museum and Art Center, conducted workshops, private instruction and lectures on the collecting of fine art and methods of conservation.

His work can be found in private and corporate collections throughout the country including the United States Air Force Collection, Washington, D.C.

Band is currently represented by the Baker Gallery of Fine Art, Lubbock, Texas; Ft. Meigs Gallery, San Patricia, New Mexico and the Herbert Halpern Gallery in New Orleans, Louisiana.

Carroll Collier

Carroll Collier has always known that he would become an artist. He entered the U.S. Army during WWII as an artist for the Transportation Corps School. The knowledge and experience gained in the army enabled him to secure a job as a commercial artist after the war had ended. Later as a freelance artist, he received numerous awards that won him the respect and admiration of artists and collectors alike.

Collier's paintings can be found in collections throughout the country, including that of former president George Bush. His works have been shown in the Dallas Museum of Fine Art and the West Texas Art Museum. Currently he is represented by galleries in Dallas, Houston, Santa Fe, Austin, Lubbock, New Orleans, Scottsdale and California.

Edwin Fulwider

Edwin Fulwider, a native of Indiana now living in Arizona, has dedicated his life and talents to art as a highly respected educator, painter and printmaker. He began his formal art training at the John Herron Art School, which is now part of Indiana University and Purdue University of Indianapolis.

His teaching career culminated in a professorship and as Chairman of the Department of Art at Miami University, Oxford, Ohio from 1949 until his retirement in 1973. His retirement enabled him to find more time for his painting and printmaking which is included in the permanent collections of many private, public and corporate collections, such as the Dayton Art Museum, Seattle Art Museum, Library of Congress and Ford Motor Co.

Fulwider has participated by invitation in numerous exhibitions, one-man shows, and has been featured in articles and books.

He is represented by D.D. Wigmore Fine Arts, Inc., New York City and Kennedy Studios—Lyle Evan Gallery, Boston, Massachusetts.

Kaye Franklin

Kaye Franklin P.S.A. began her art career in 1975 while living in Colorado, but it wasn't until she moved with her family to Texas in 1979 that she began her serious quest for the best schools and instructors available. Franklin's dedicated pursuit of excellence has won her the deepest respect of her students, peers and serious collectors.

Upon invitation she conducted a pastel workshop in Paris, France in addition to her normal schedule of workshops and classes in Texas.

She has been the recipient of many honors and awards from national competitions which culminated in her election to signature membership in the Pastel Society of America.

Franklin is represented by Hensley Gallery Southwest, Taos, New Mexico and Stellar Art Gallery, Wichita Falls, Texas.

Tony Saladino

A native of New Orleans and educated at Louisiana State University, Tony Saladino moved to Texas in 1970 and began an intensive study of art. He began painting by trying almost every medium and exploring many techniques and styles. The creative process has been all consuming for Saladino. He did an extensive self-study in all areas of two-dimensional art. He read, experimented, visited museums and studied other artists' work.

Both a printmaker and painter, Saladino's work shifts from large color and form statements in oil or acrylic to small intaglio prints. His work is in the collections of museums and universities worldwide.

Contributors

George M. Bruestle *A.N.A. (1871-1939)*
Studied: Art Students League, New York; Academy Collarosi, Paris
Membership: Associate National Academy of Art and Design; Allied Artists of America
Media: Oil, Watercolor

Kent Day Coes *N.A.*
Studied: Grand Central School of Art, New York; Art Students League New York; New York Univ.
Membership: National Academy of Art and Design N.A.; American Watercolor Society A.W.S.; Allied Artists of America; New Jersey Watercolor Society; Salmagundi Club New York
Media: Watercolor

Mario Cooper *N.A.*
President Emeritus A.W.S.
Studied: Otis Art Institute, Los Angeles; Chouinard Art School, Los Angeles; Grand Central Art School, New York
Membership: National Academy of Art and Design; American Watercolor Society; Audubon Artists; (Hon. Men) Royal Watercolour Society, London, England
Media: Watercolor, Oil

Henry M. Gasser *N.A. (1909-1981)*
Studied: Newark School of Fine and Industrial Art, New Jersey; Art Students League, New York
Membership: National Academy of Art and Design; American Watercolor Society; Audubon Artists
Media: Watercolor, Oil

Philip Jamison *N.A.*
Studied: Philadelphia Museum School of Art
Membership: National Academy of Art and Design; American Watercolor Society; Philadelphia Watercolor Club
Media: Watercolor, Oil

Roy M. Mason *N.A. (1886-1972)*
Studied: Self-taught
Membership: National Academy of Art and Design; American Watercolor Society; Allied Artists of America, New York; Audubon Artists; Philadelphia Watercolor Club; Rochester Watercolor Club; Buffalo Society Artists
Media: Oil, Watercolor

Ila McAfee
Studied: West Lake School of Art, Los Angeles; Haz Art School, Los Angeles; Western State College; Painting with James McBurney, Chicago; Sculpture with Loredo Taft; Art Students League, New York; National Academy of Art and Design
Media: Oil, Watercolor, Sculpture

F. Luis Mora *N.A. (1874-1940)*
Studied: Boston Museum of Fine Arts School; Art Students League, New York
Membership: National Academy of Art and Design; American Watercolor Society
Media: Oil, Watercolor

John C. Pellew *N.A. (1903-1993)*
Studied: The Penzance School of Art, England
Work: Metropolitan Museum of Art, New York; Butler Institute of Art, Youngstown, Ohio; New Briton Museum of Art, Connecticut and many others.
Membership: National Academy of Art and Design; American Watercolor Society; Allied Artists of America; New Jersey Watercolor Society; Salmagundi Club, New York
Media: Watercolor

Edgar A. Whitney *A.N.A. (1891-1990)*
Studied: Cooper Union, New York; Art Students League, New York; Columbia University, New York; Grand Central School of Art, New York; Cincinnati Art College, Ohio; Art Academy of Cincinnati, Ohio
Membership: Associate National Academy of Art and Design; American Watercolor Society; Philadelphia Watercolor Club; Southwestern Watercolor Society; (Hon. Men.) International Society of Marine Painters
Media: Watercolor

Index